The Hook, The Hill and Lilly too!

Sunrise to Sunset imagery in Capitola, California from 2012 to 2016 and Lilly, the cat next door.

By David Mrus

CONTENTS

ACKNOWLEDGMENTS

I dedicate this book to my Father, George Mrus whose lifelong interest in all things camera still resonates with Me. My Facebook™ Friends whose "likes" provided encouragement to continue this project and those who have purchased my photography to grace their Homes or Businesses. My neighbors, Anne & Marshall for their patience as I started my truck engine each day for sunrise service and as Lilly's guardians. There is a special place in this book for Lilly, the cat next door.

High resolution copies of this four year project in various formats are available at:

http://Solaremergence.smugmug.com

THE PREFACE

This book is photography of sunrises and sunsets taken in Capitola, California and Lilly the cat next door. The photographs are generally framed with diagonals of perspective, the opposite corners of sunrise along Rockview Drive, East Cliff Drive or Opal Cliffs Drive with a line of sight towards the sunset bluffs of Depot Hill. Lilly, the cat next door is an ever present figure in my photography. She is a cat who selects the moment, place and time.

Within these pages, I share my secrets so that you may explore on your own. I hope that you enjoy this multiyear journey of observation.

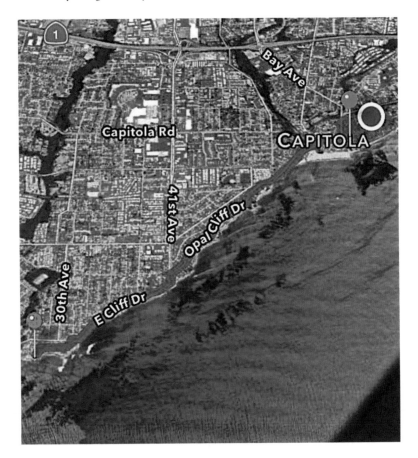

David Mrus
Capitola, Ca.
June 2016

THE INTRODUCTION

The themes of this book are the distillation of over 80,000 photographs taken between 2012 and 2016 in Capitola, California. They are organized by chapter and location so the Reader may frame the imagery. Within each chapter, the photographs follow the narrative of my exploration. The locations are readily accessible given the tides and weather of the moment for anyone to visit.

Sun Pillars, Altocumulus and Crespuclar clouds are regular components in my photography and on rare occasion, Kelvin-Helmholtz waves. The geology of Monterey Bay is dynamic with coastal cliff erosion, sand transport and tidal action that brings change every day. A trifecta in observation is the conjunction of a full moon and low tide synchronized with sunrise. The imagery is coined "Visual Speedbumps" in that the observer's eye wanders from the foreground to the background horizon line.

The objects in my photography represent stage-props and include Surfers, Sea lions, and Seagulls. Surfers in wetsuits appear as Rodin sculptures with conformed bodies in motion. I have learned to look in the opposite direction of sunrise and sunset for cast shadows, reflections and pools of light.

The imagery is as observed with the Gear used at the time. Apple Aperture ™ photo imagery software is used for this book. The primary edit tools are definition and highlights with the shadows increased for book production.

The Gear

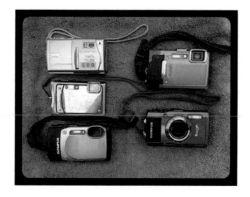

I have used 5 types of Olympus Cameras of which the last 4 are the Tough™ brand which are water and shockproof.

CHAPTER 1 END OF THE ROAD

My first sunrise images for this book began at the end of the road or "Short Stack Sunrise". The imagery captured is along Grand Avenue with the Cement Ship, Moss Landing Stacks and the Lights of Monterey.

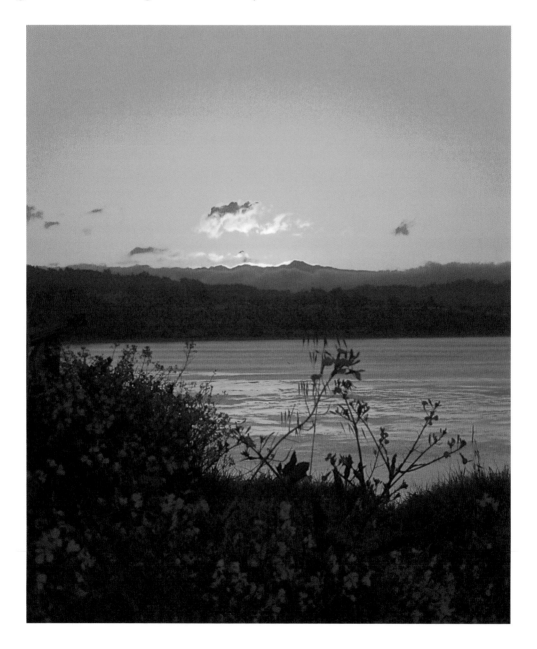

Apr. 15, 2013

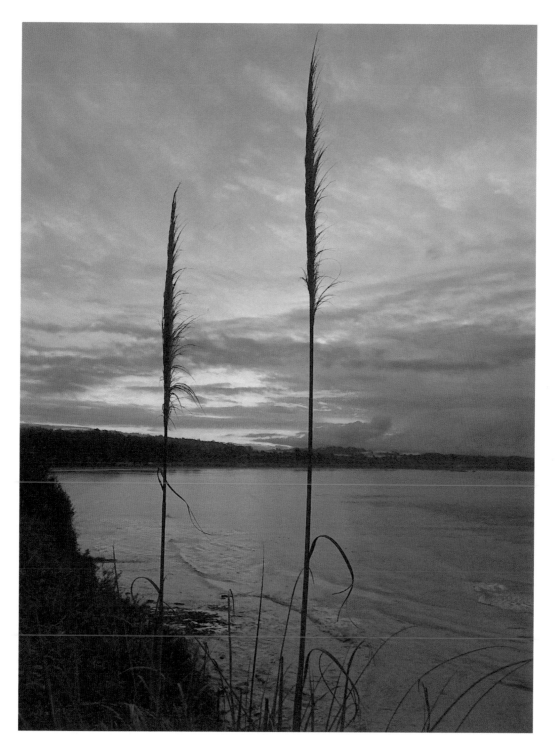

Mar. 23, 2015

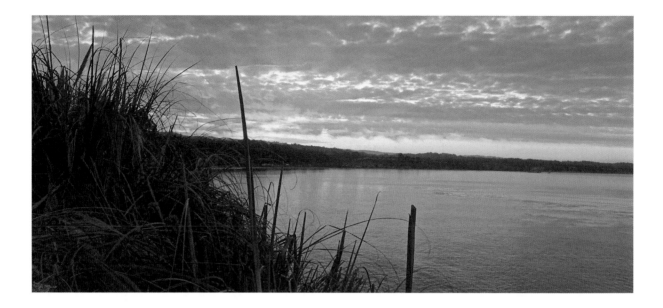

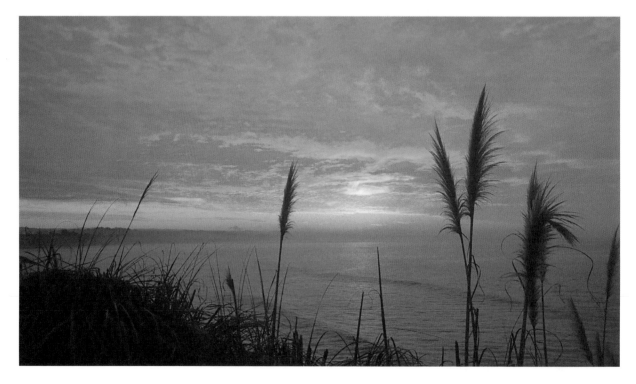

May 12, 2015 & Jan. 8, 2016

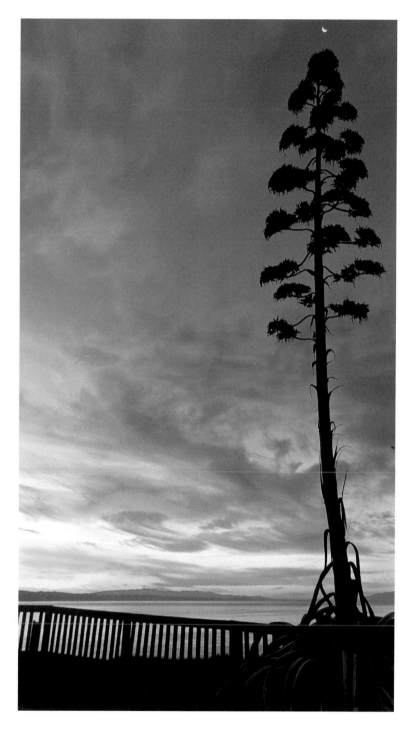

Nov. 5, 2015

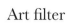

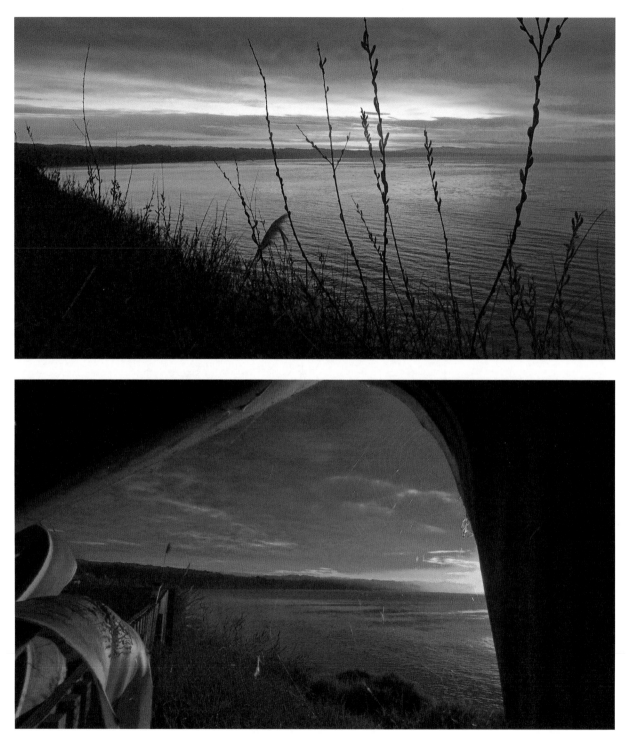

Nov. 16, 2014 & Jan. 22, 2015

CHAPTER 2 THE WHARF

I start my sunrise projects with imagery from the parking area on Cliff Drive overlooking the Wharf. This position provides a panoramic view of Monterey Bay and a precursor of things to come.

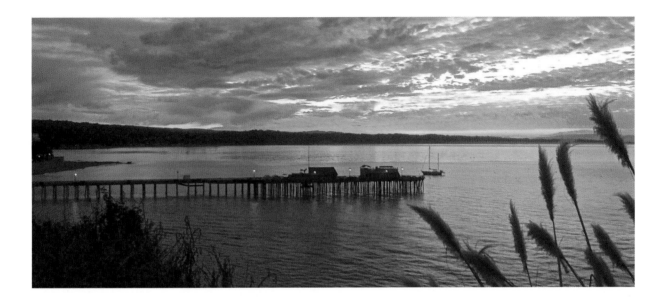

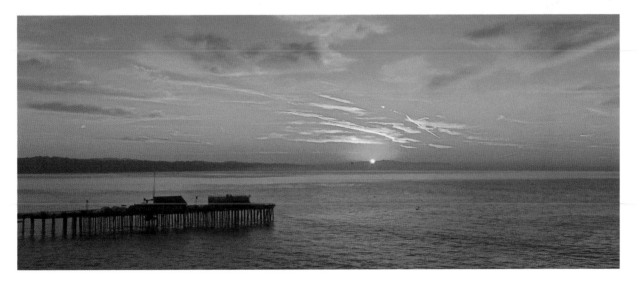

Nov. 14, 2012 & Jan. 4, 2013

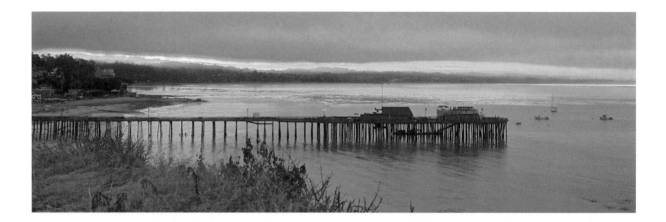

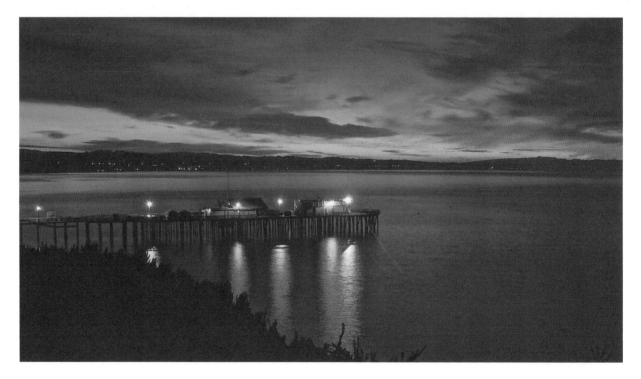

May 27, 2013 & Jan. 3, 2014

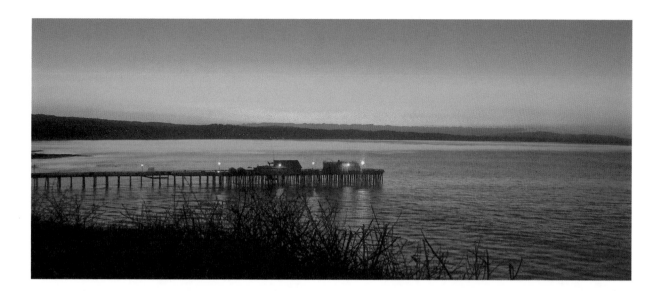

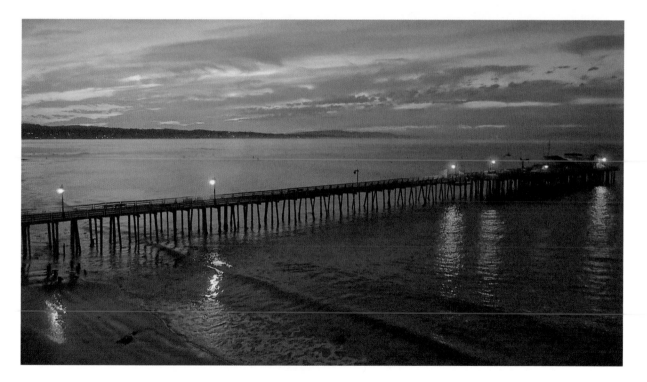

Mar. 12, 2014 & Oct. 14, 2015

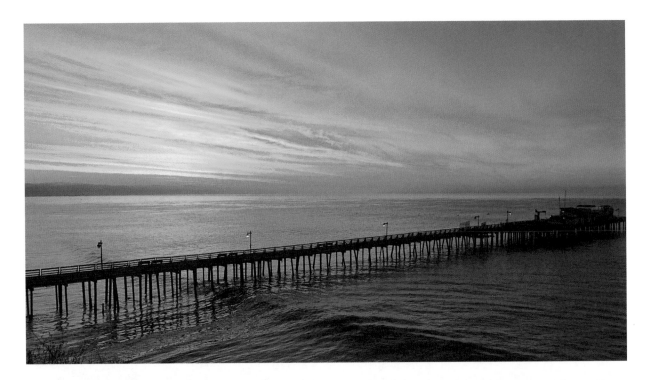

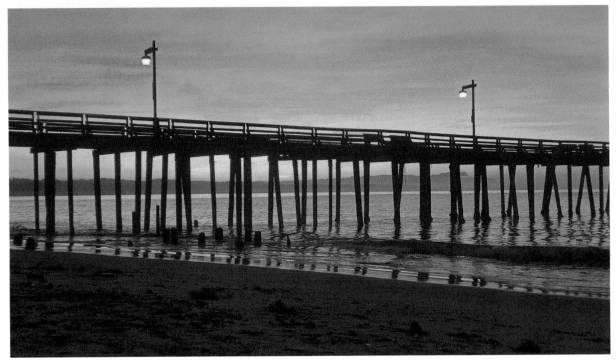

Oct. 23, 2015 & Nov. 18, 2015

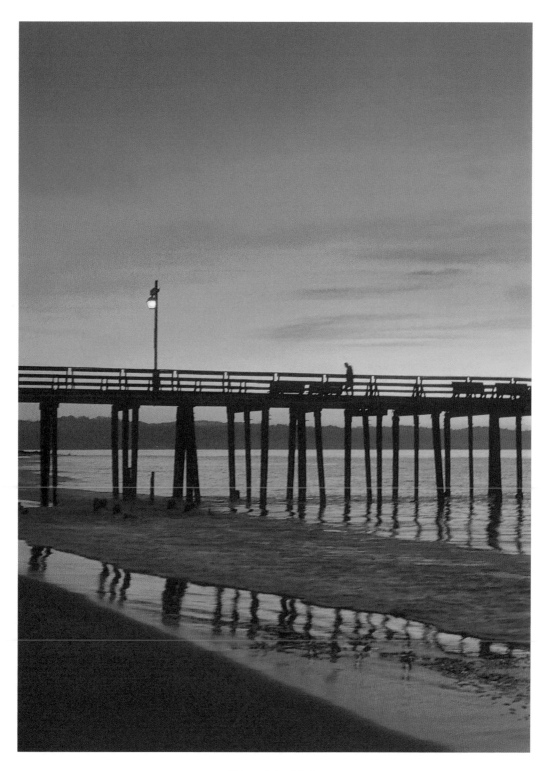

Nov. 18, 2015

CHAPTER 3 THE HOOK

The Steps lead down to the water from the parking lot and engage Me in different vantage points. My photography begins at the top of the stairs where I frame a portion of the Monterey Cypress looking toward the Moss Landing Power Stacks. The iconic trees are the frame of many decals, bumper stickers and the like. The base of the stairs provides a position to observe the high tide ricochetting between the coastal armoring and beach access. Tides permitting, I venture south towards the Village or north along the ledge and to the marine terrace outcrop I coin, "The Hump".

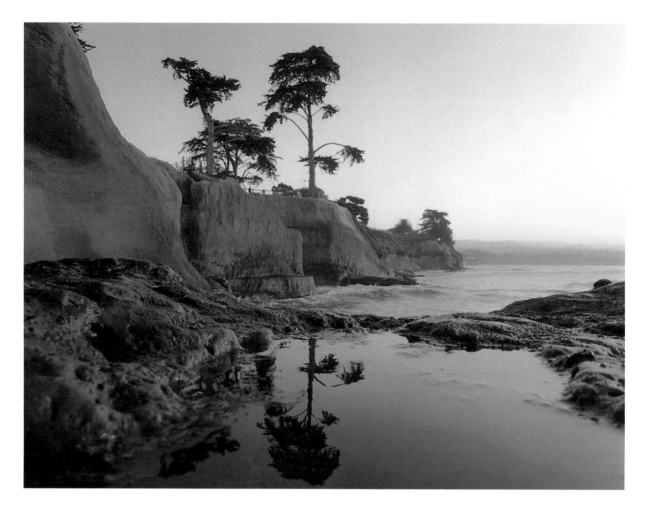

Oct. 4, 2015

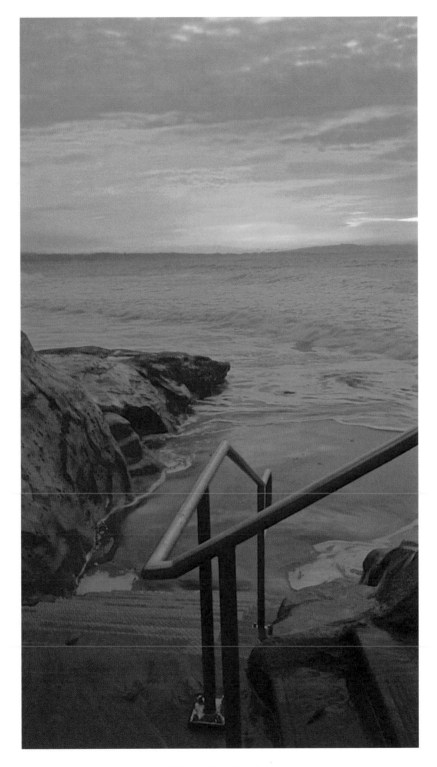

Nov. 29, 2012

Opal Cliffs looking towards Depot Hill from the Hump

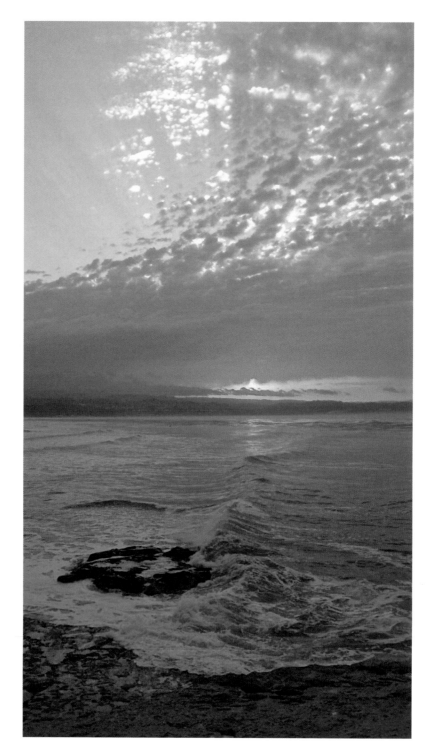

May 5, 2013

The Hump

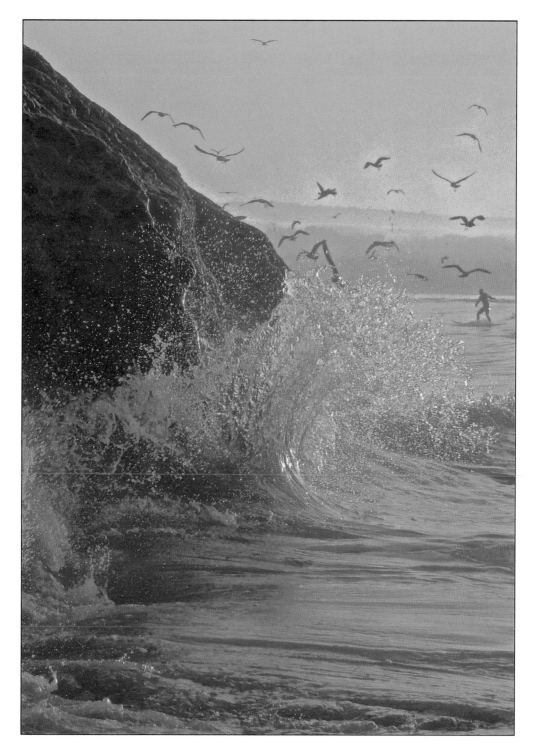

Sep. 20, 2013

The Grotto imagery or Paleo sunrise with narrow and tall crawl spaces

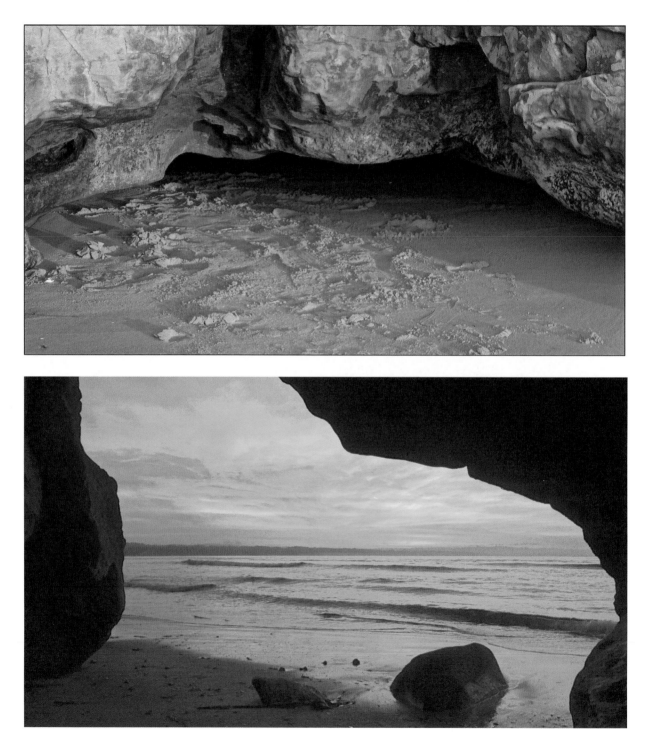

Oct. 10, 2014 & Jan. 29, 2013

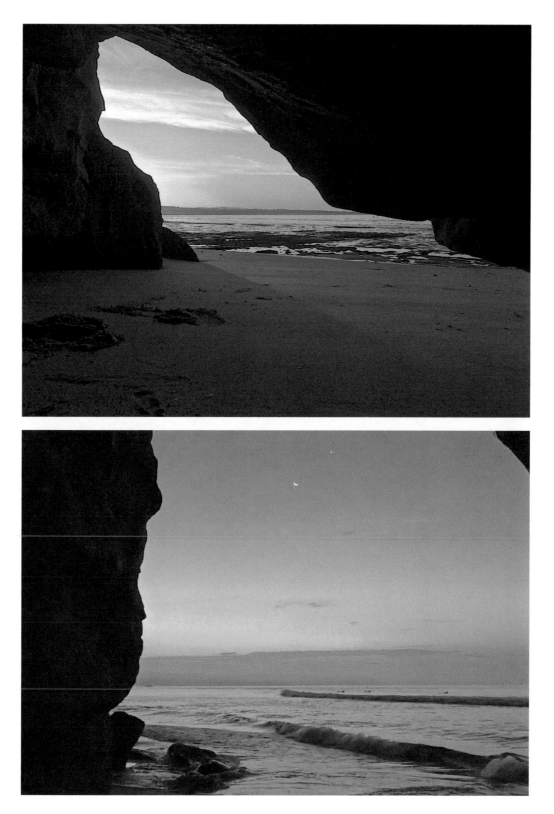

May 2, 2014 & Sep. 10, 2015

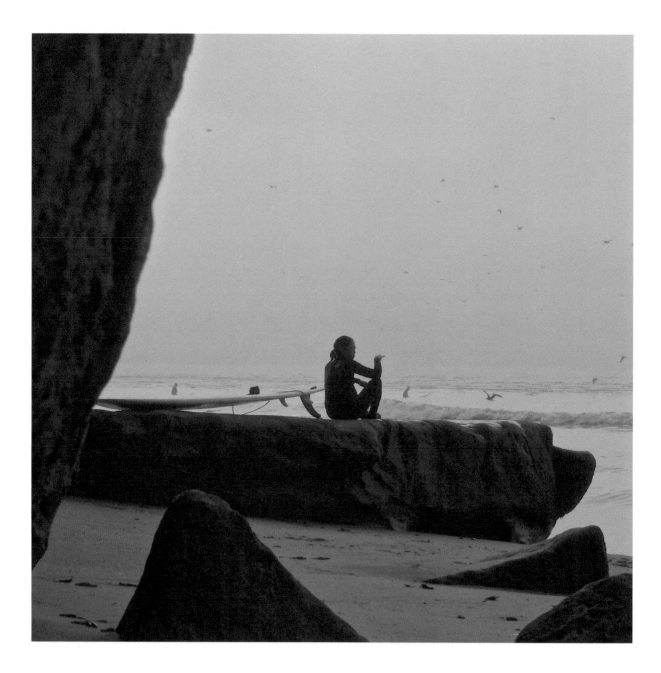

Sep. 22, 2013

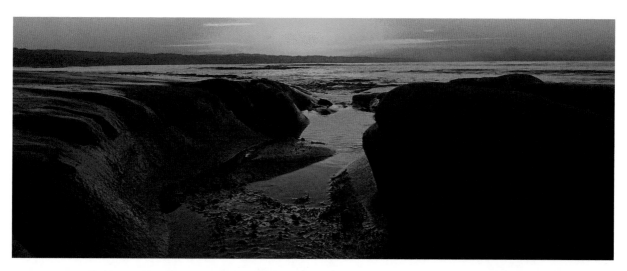

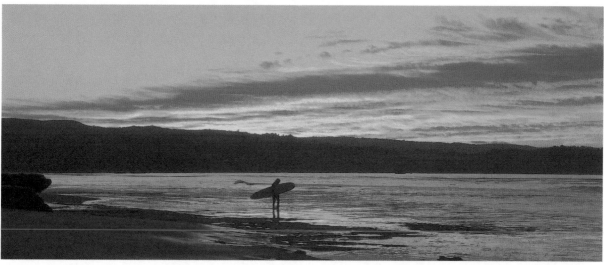

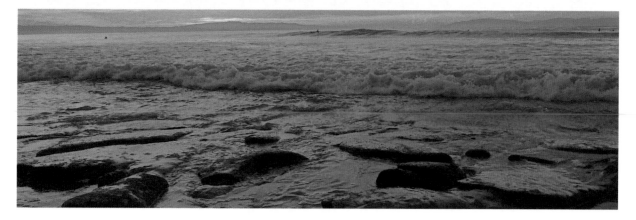

Jul. 23, 2014

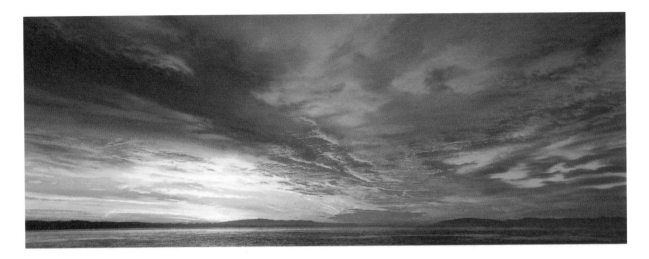

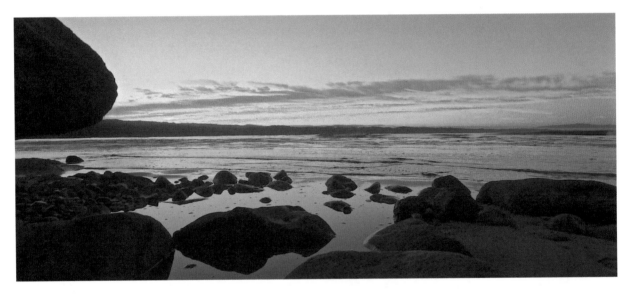

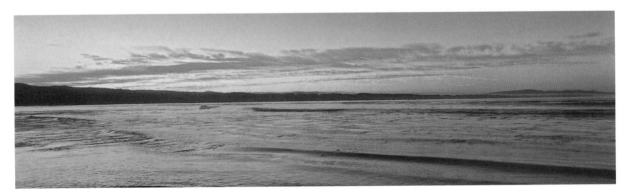

Nov. 18, 2014, Mar. 8 & Nov. 30, 2015

Walking south towards the Village there was a Surf God and then....

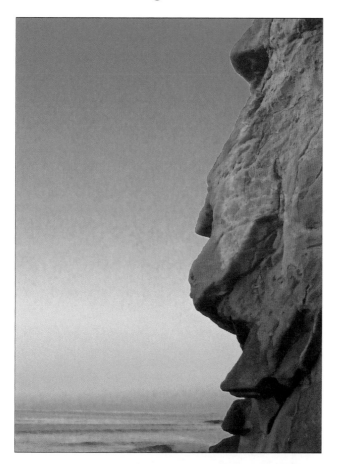

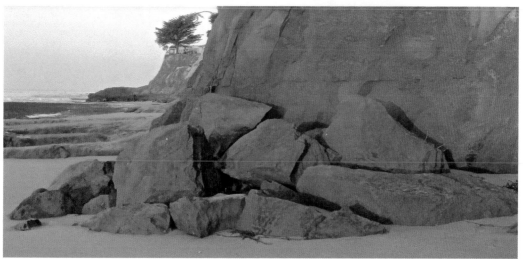

Dec. 5, 2013 & May 1, 2014

Walk to the Village on a full moon lowtide in summer.

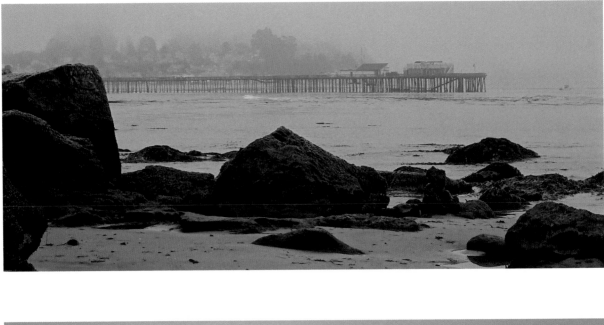

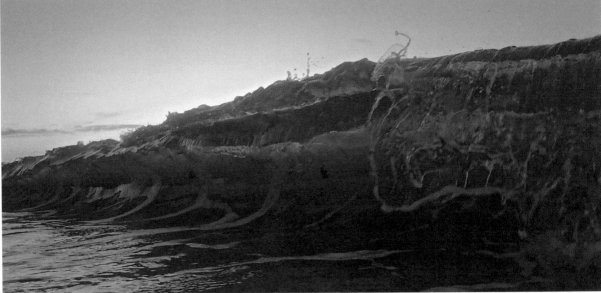

Jun. 17 & Ap. 6, 2015

Add you own photo imagery

The Hump

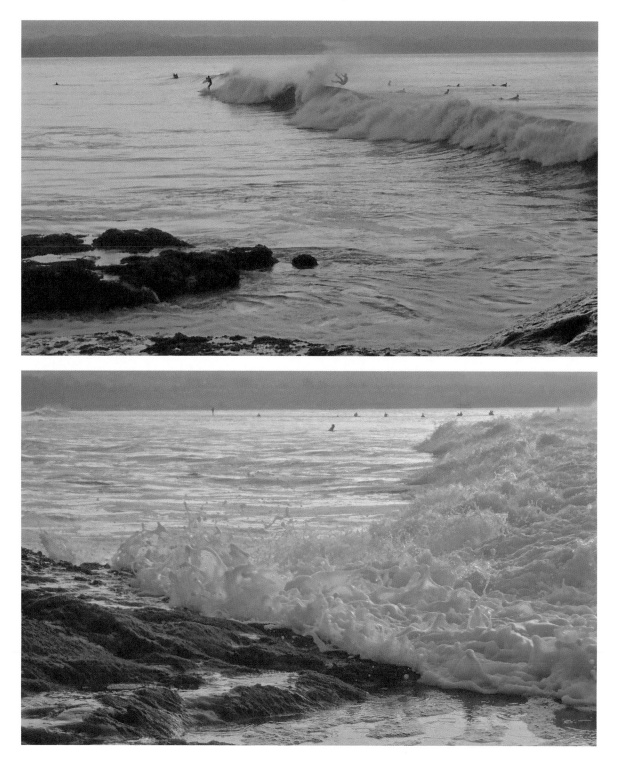

Sep. 5, 2015

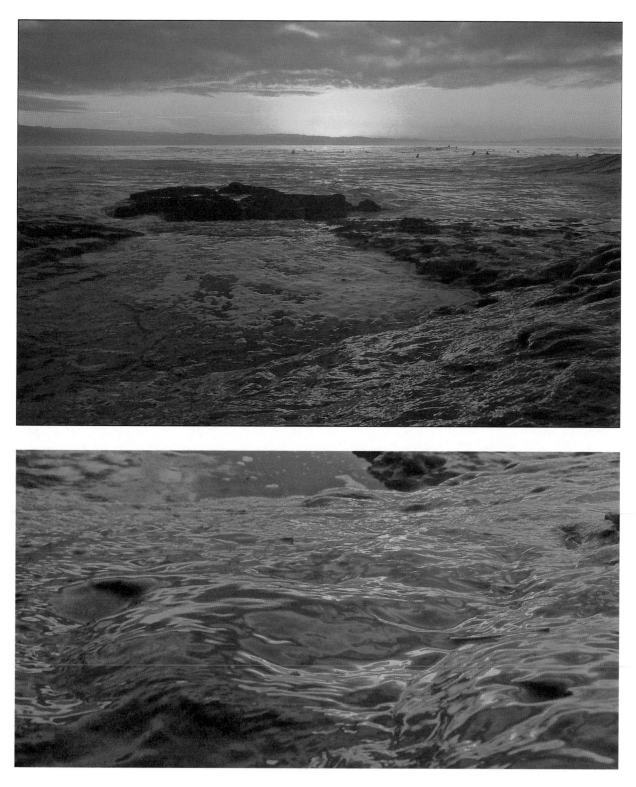

Sep. 30, 2013

Ryan Halpin

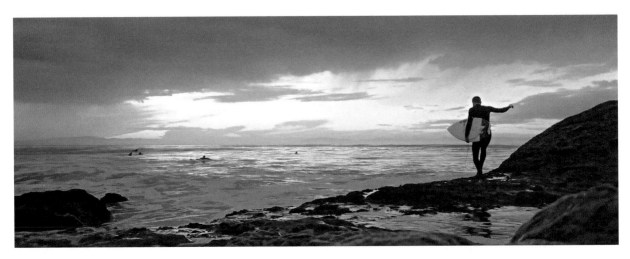

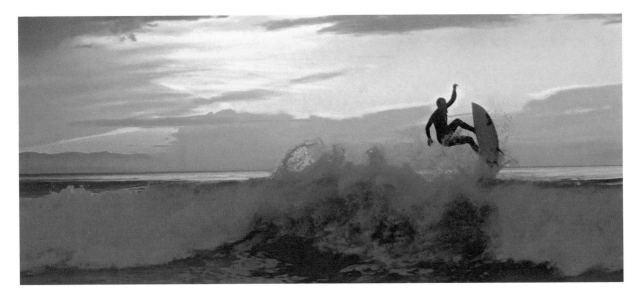

Oct. 15, 2015

Then, there are moments on Opal Cliff Drive

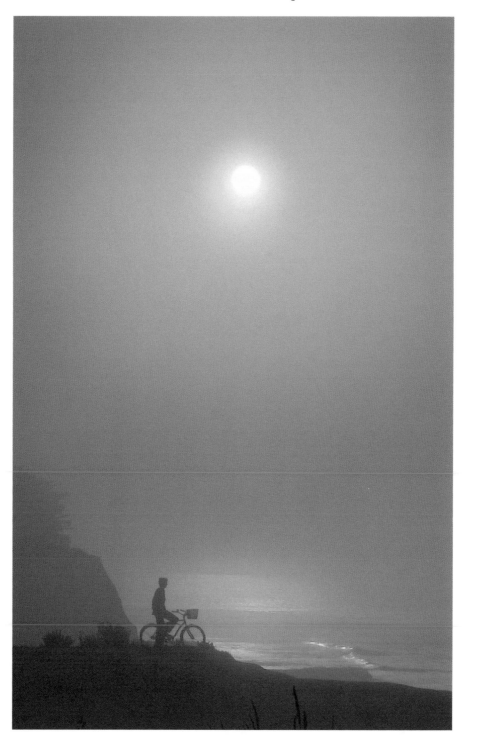

Jul. 14, 2014

CHAPTER 4 PLEASURE POINT

The access from the Hump to Pleasure Point is a low tide beach walk past Jack O'Neil's house. The sunlight reflects off the house's windows.

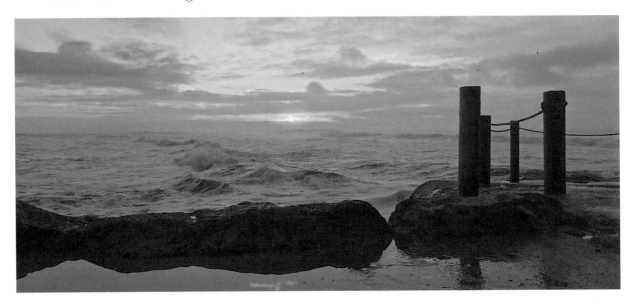

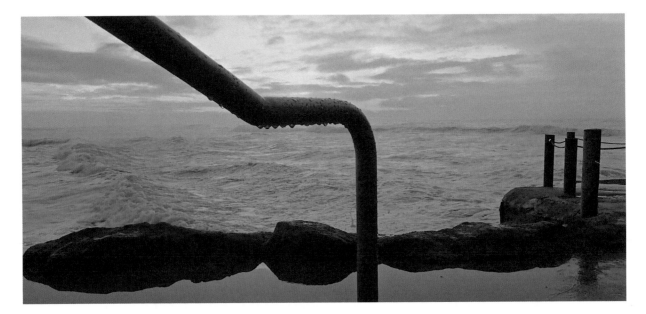

Jan. 7, 2016

That's the house with sunrise window reflections

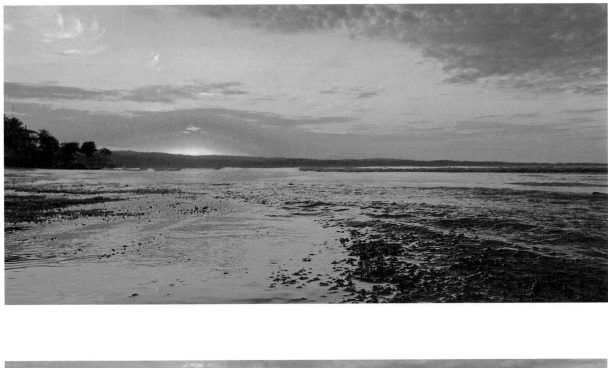

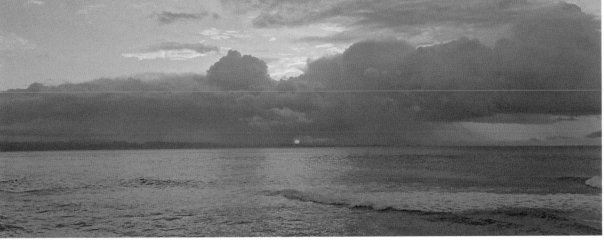

Jul. 20 & Nov. 9, 2015

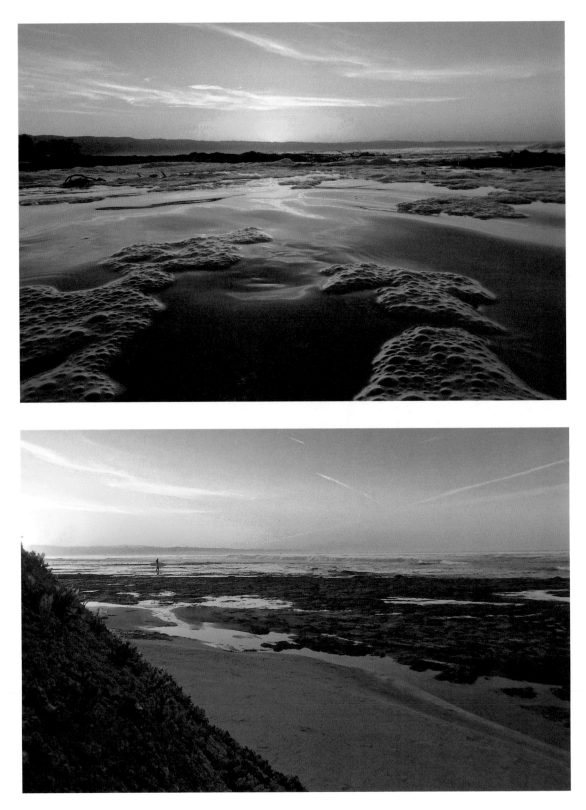

Apr. 29, 2014

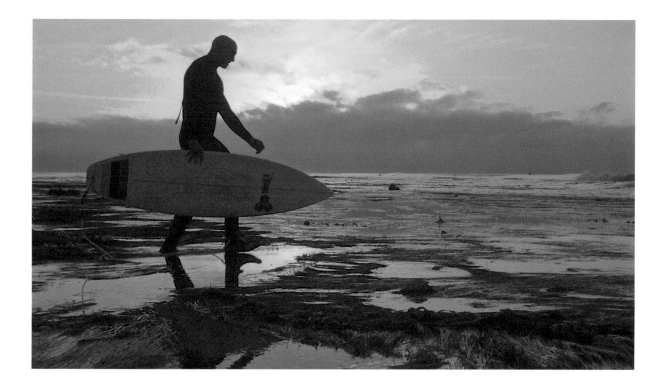

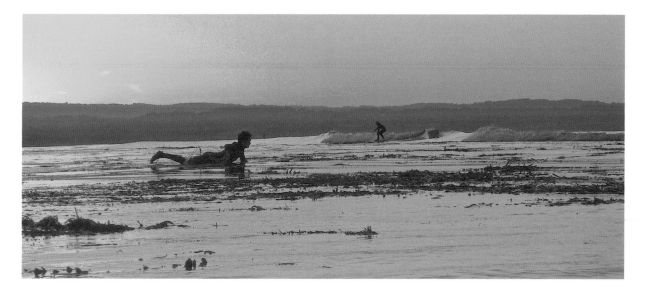

Apr. 11, 2013 & May 13, 2014

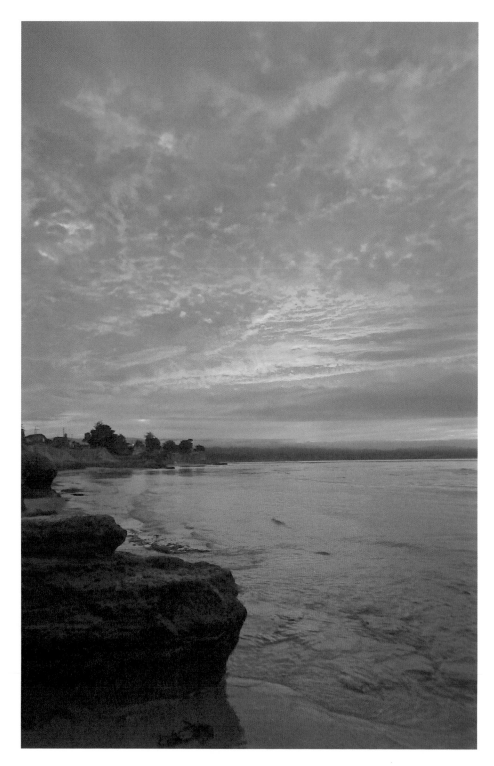

Jul. 22, 2014

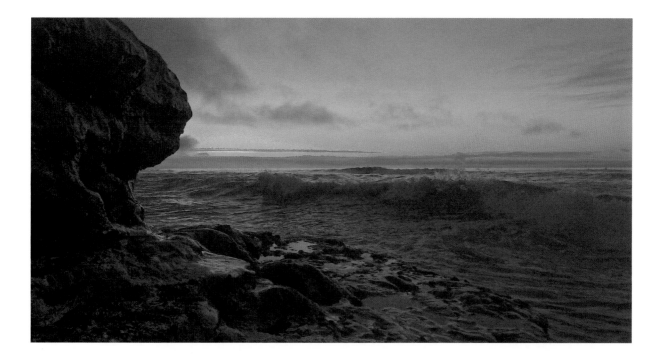

Oct. 20, 2014

CHAPTER 5 SEWER PEAK

The concrete retention wall is a launch point over the Rip Rap and into the waves. My friend Zach Moranville profiles the sunrise in February of 2015. This is accessible from a staircase on Pleasure Point Drive.

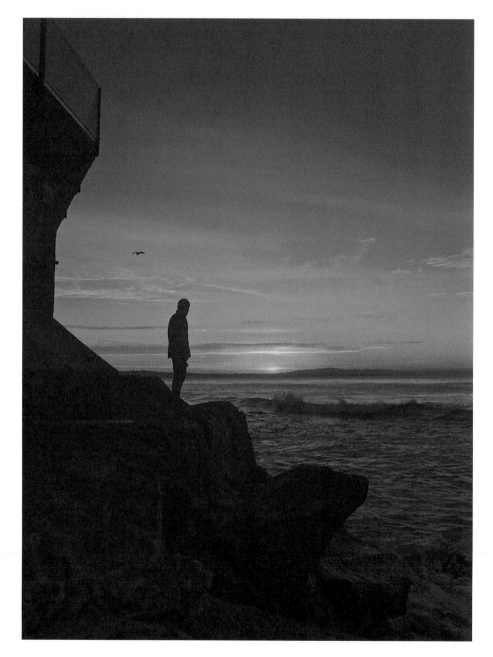

Feb. 1, 2015

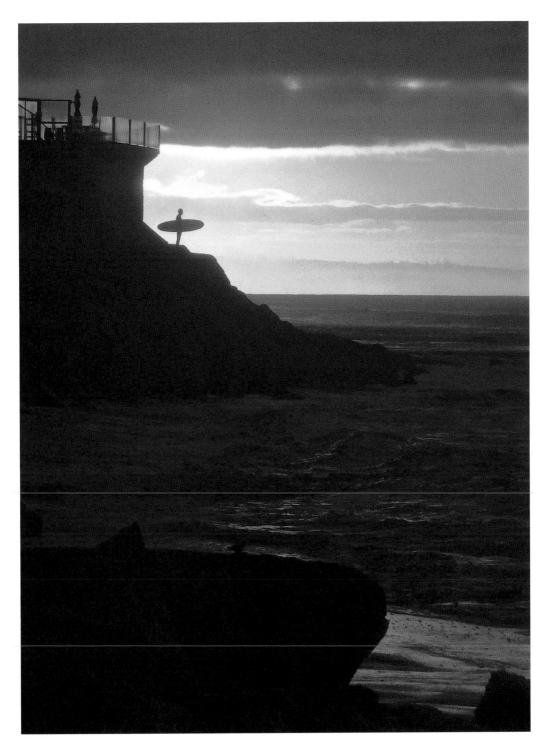

Mar. 17, 2014

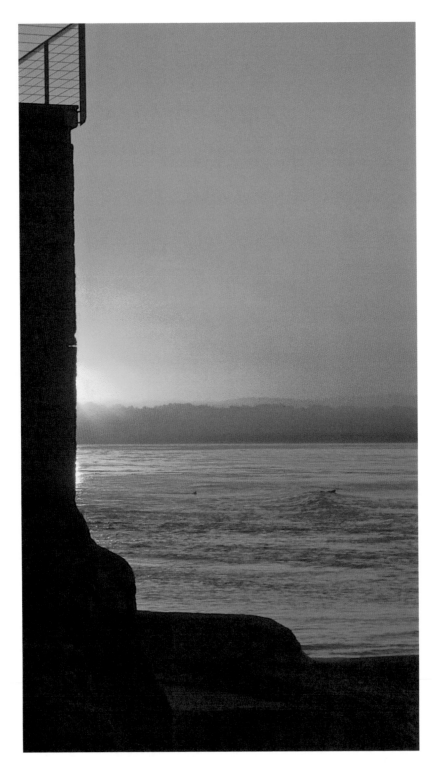

Apr. 16, 2013

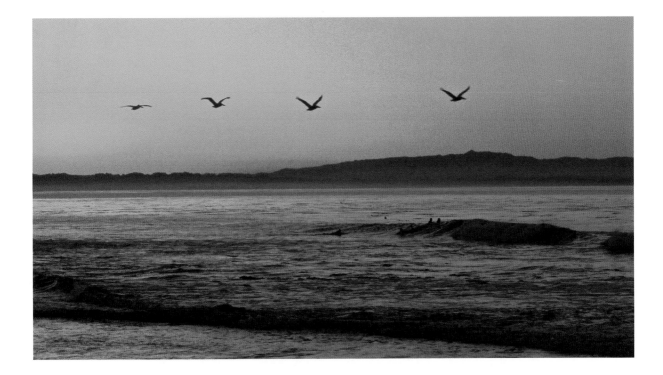

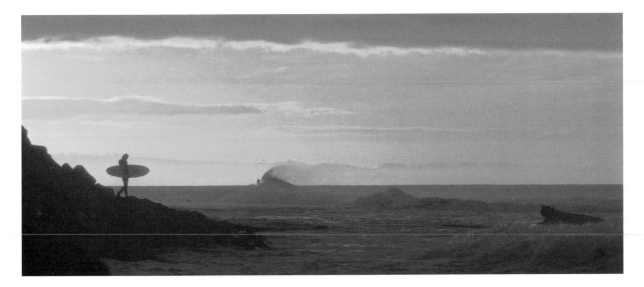

Feb. 15, 2013 & Mar. 17, 2014

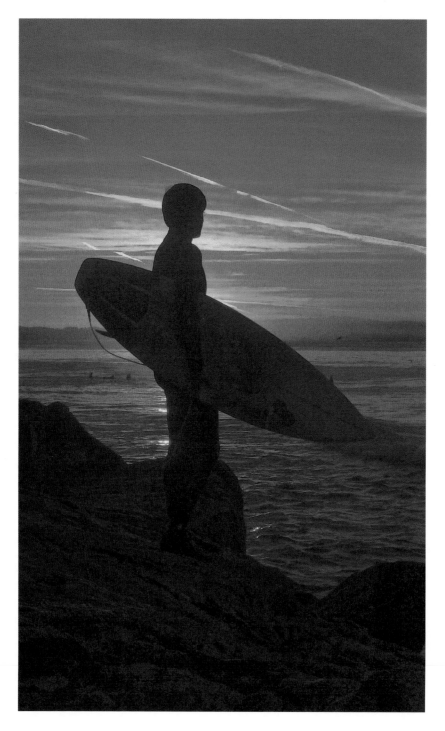

Nov. 6, 2014

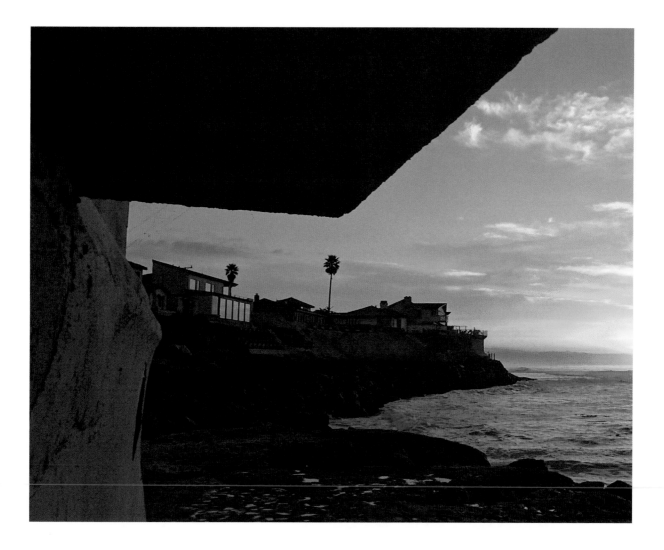

Feb. 26, 2016

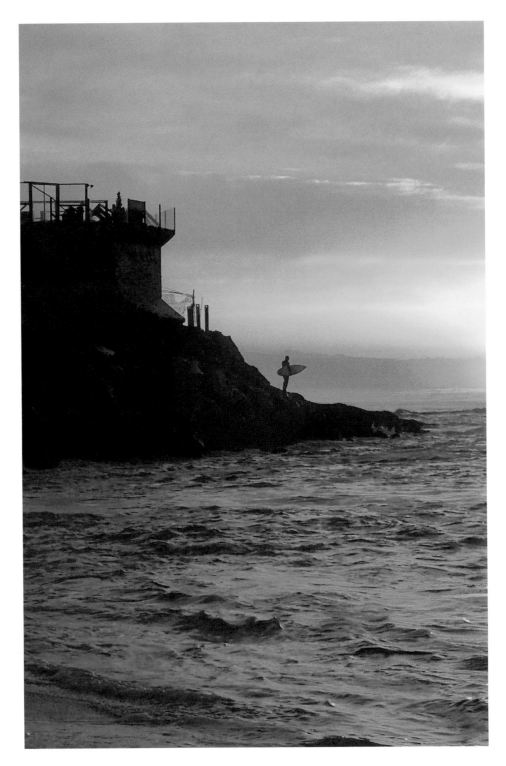

Mar. 14, 2015

CHAPTER 6 ROCKVIEW

Rockview Drive is the end of the road. The public staircase provides access to what I call, "Thirty-Second Beach". The beach is accessible and visible only at low tide. Reflection pools are a thread in framing of the moment.

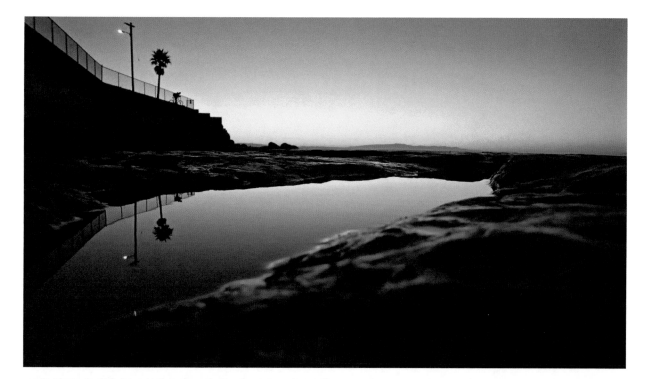

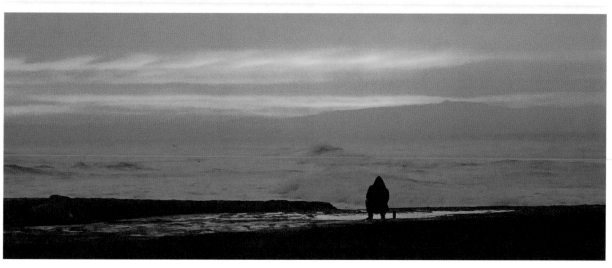

Oct. 30, 2015 & Jan. 14, 2016

Kelvin-Helmholtz waves and Full Moon

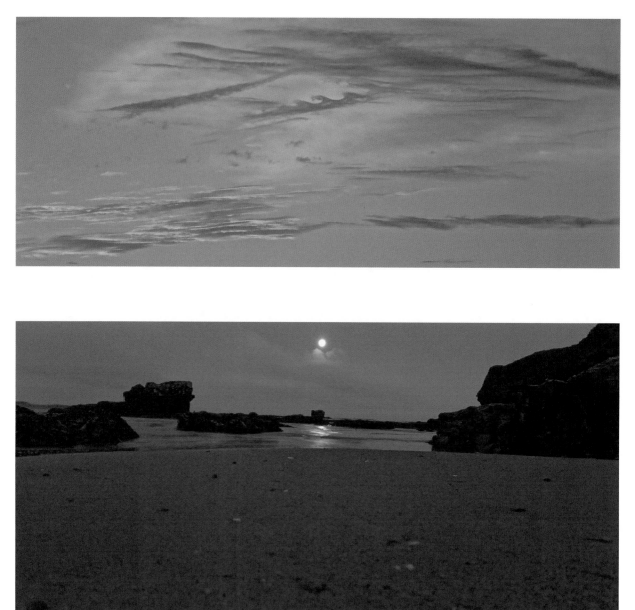

Feb. 6, 2015 & Jun. 13, 2014

Angel Martinez and Seagull sunrise

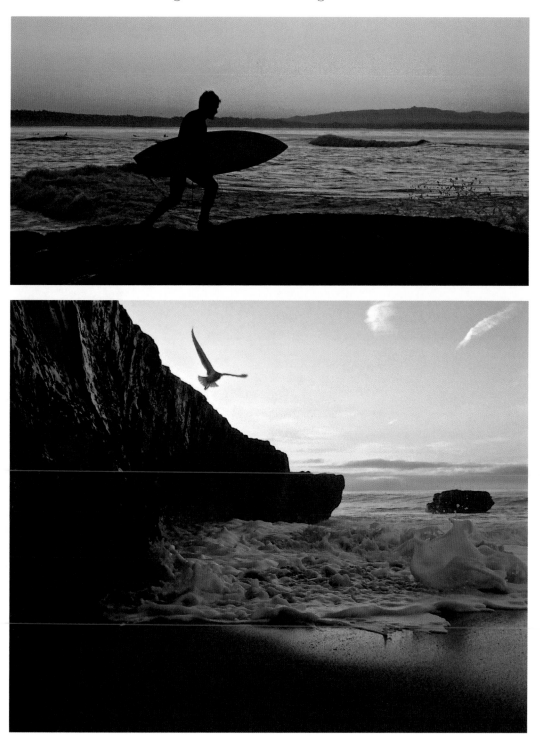

Nov. 29, 2015 & Jan. 8, 2014

The reflection pool

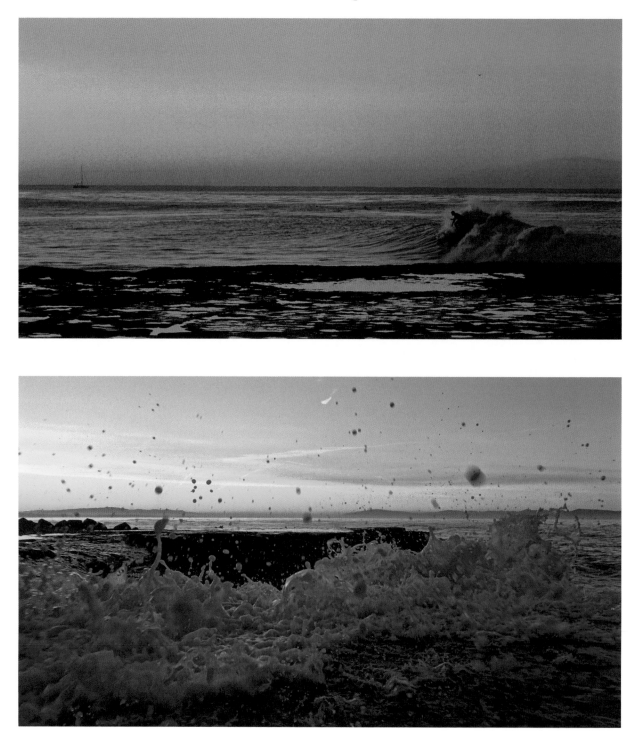

Dec. 31 & Nov. 4, 2015

On Rockview terrace there is a v-groove that I call The Notch

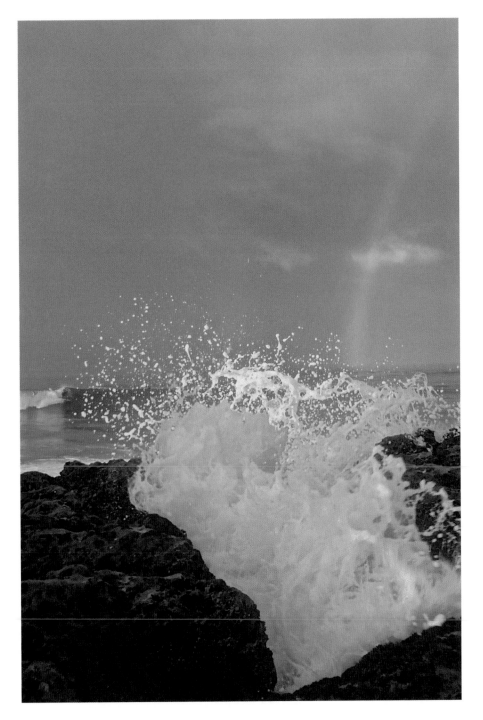

Feb. 19, 2014

There is a crotch to anchor on the vertical face to capture the leap

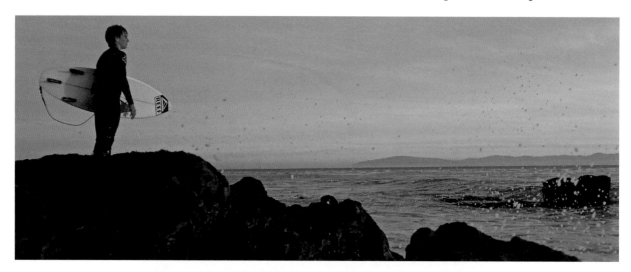

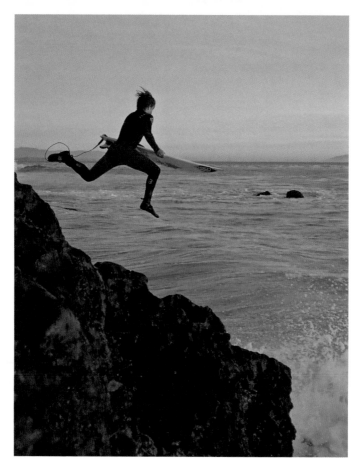

Dec. 9, 2015

Sunset, Surfers and Splisches

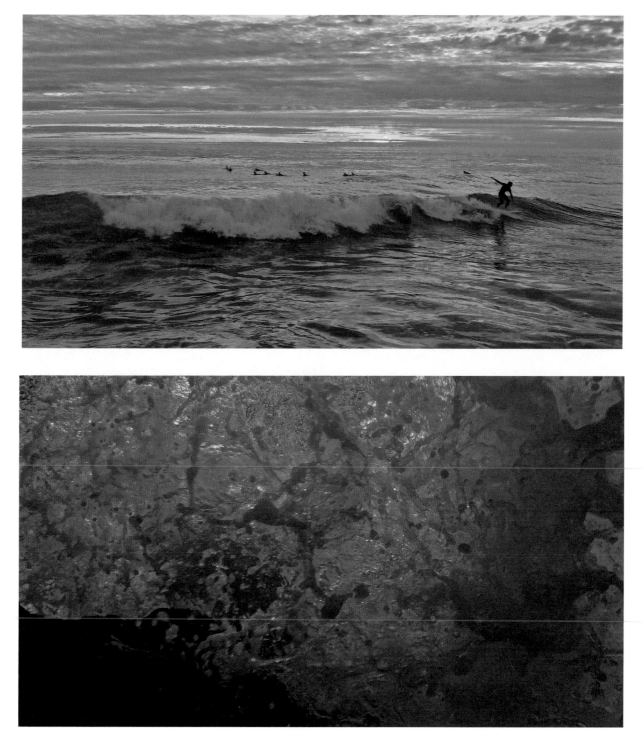

Jan. 8, 2015 & Oct. 27, 2014

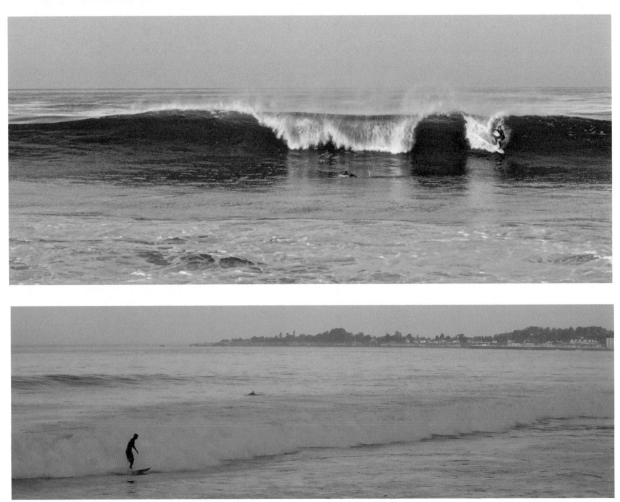

Dec. 25, 2013 & Feb. 27, 2013 & Apr. 30, 2014

Sunset

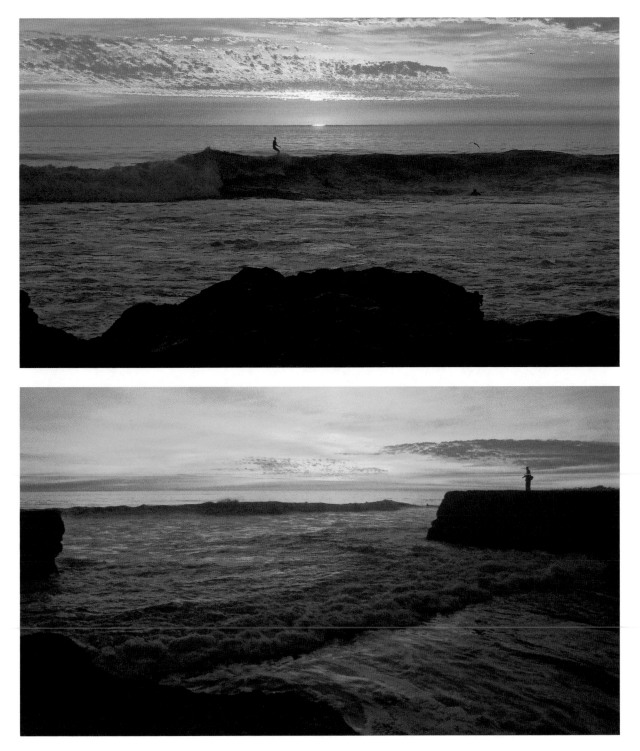

Dec. 16, 2013

CHAPTER 7 THE CRACK AT ROCKVIEW

I have observed a portion of the marine terrace deconstruct over time. This imagery is a slow motion study of the forces of nature. It starts with a fissure, then slowly begins to open and finally tumbles into the Sea.

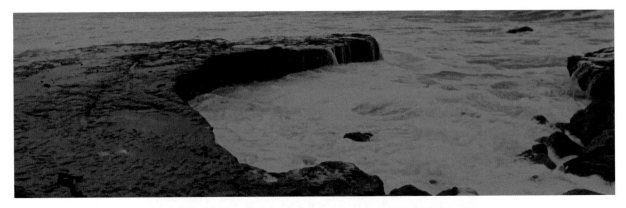

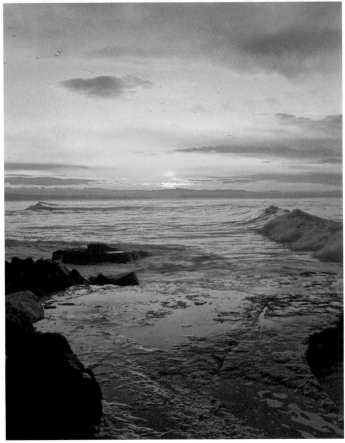

Dec. 27, 2012 & Jan. 10, 2013

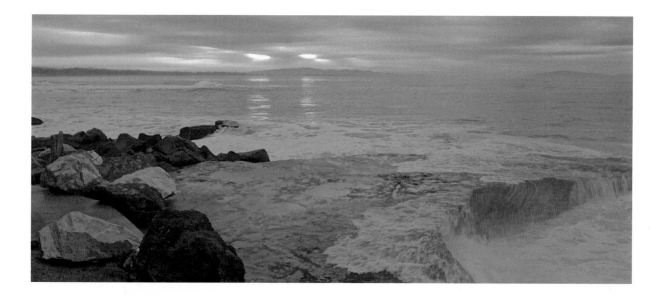

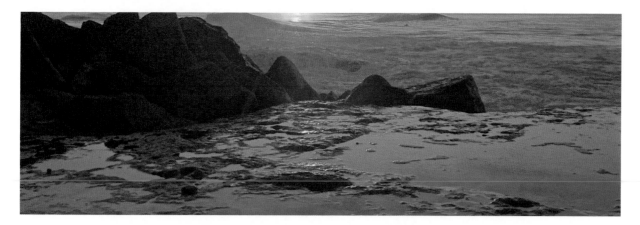

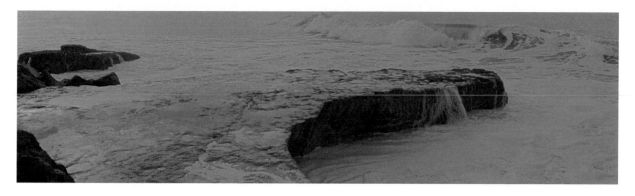

Jan. 23, Feb. 7 and Mar. 8, 2013

Fast forward 9 months

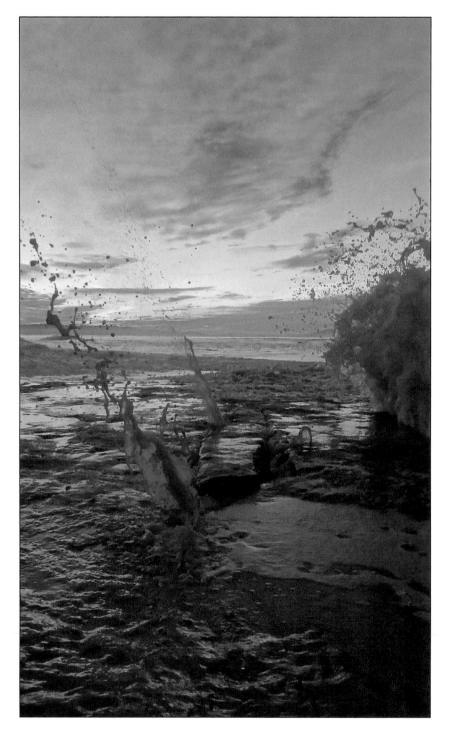

Dec. 16, 2013

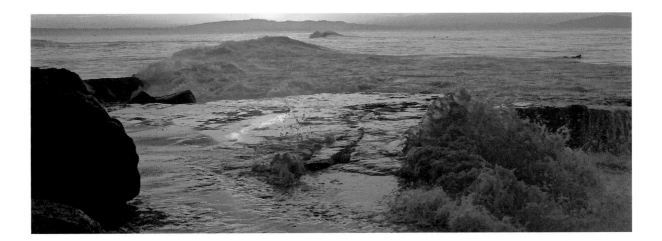

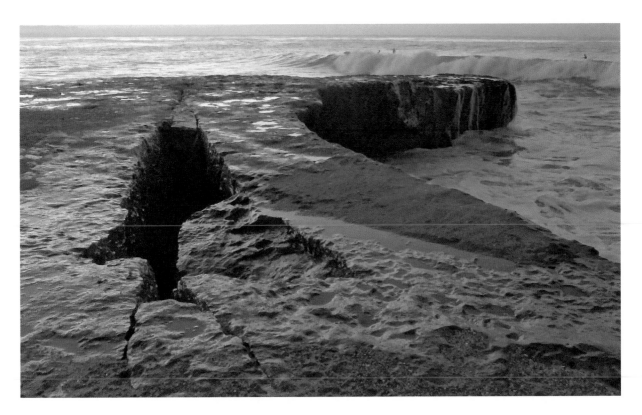

Dec. 31, 2013 & Jan. 31, 2014

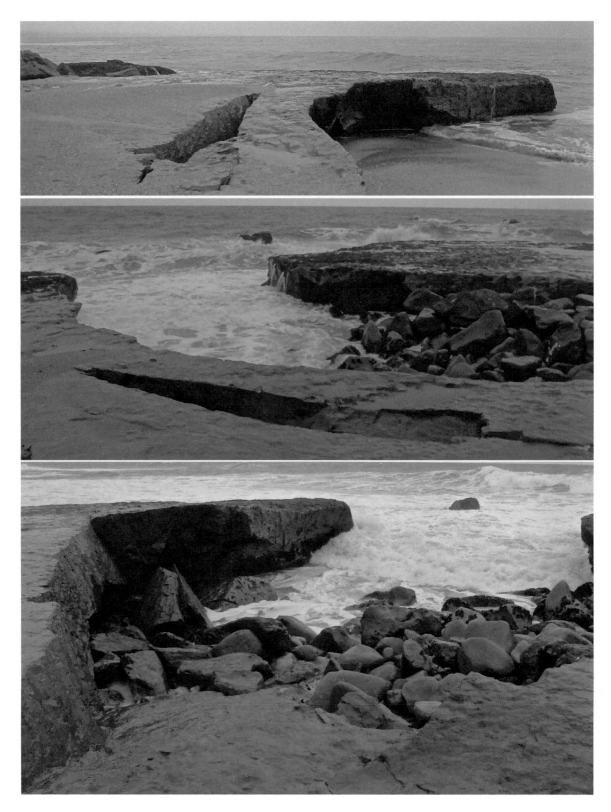

Feb. 8, 25 & Mar. 2, 2014

Jul. 12, & Dec. 20, 2014

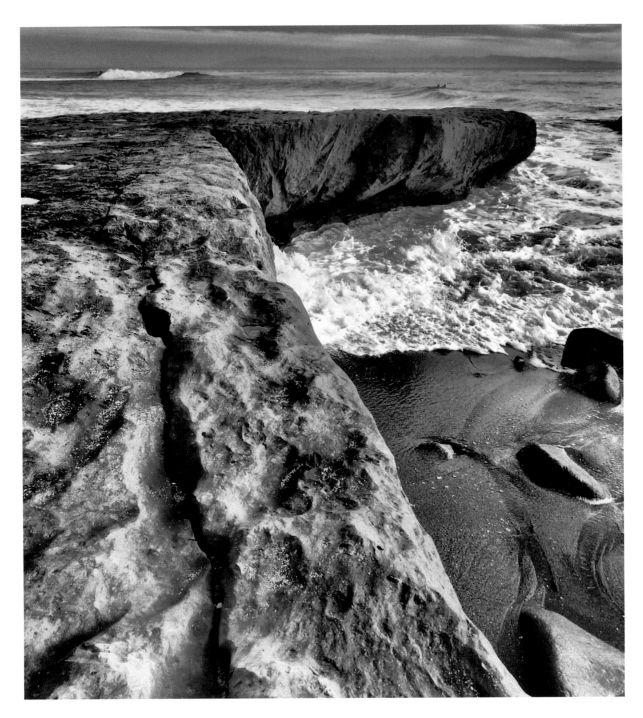

Jan. 28, 2015

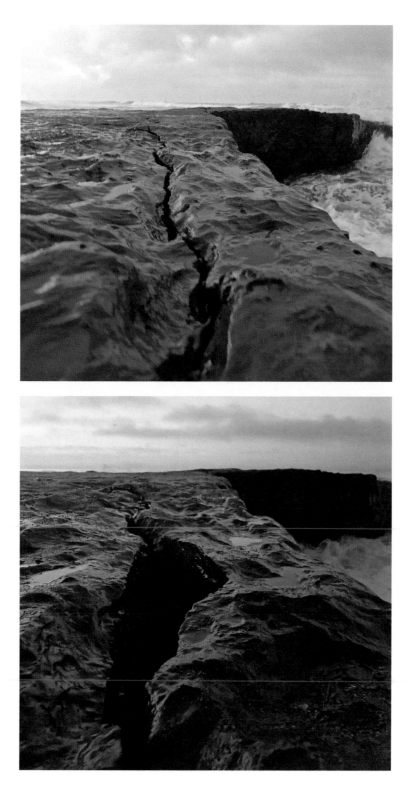

Feb 9 & Mar. 31, 2015

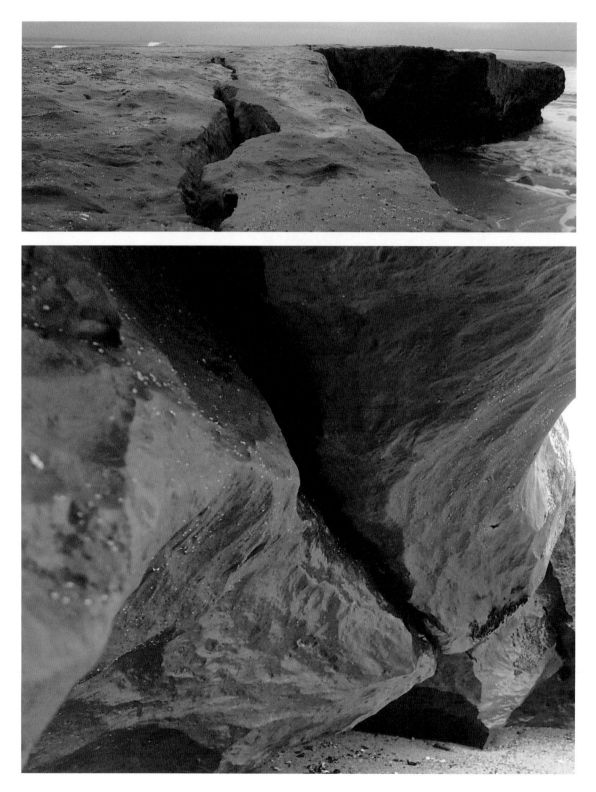

May 9, 2015

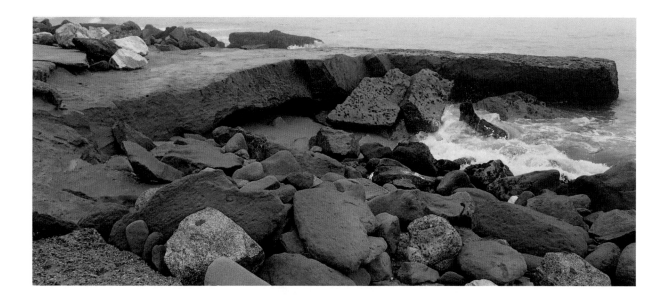

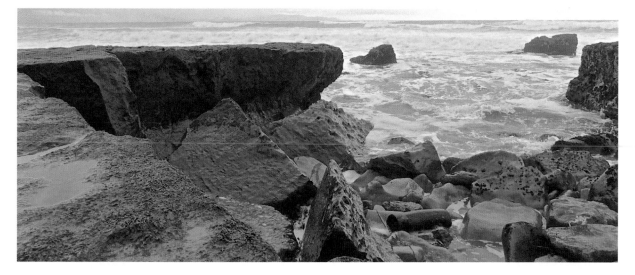

Oct. 2, 2015 & Jan. 6, 2016

CHAPTER 8 THE VILLAGE

Capitola Village, a seaside destination for those captured by its beauty, sandy beaches and surf. The Classic Car weekend and other events make it a year-round destination for friends and families. This chapter has daytime and nightime imagery.

The fog lifted in 10 minutes

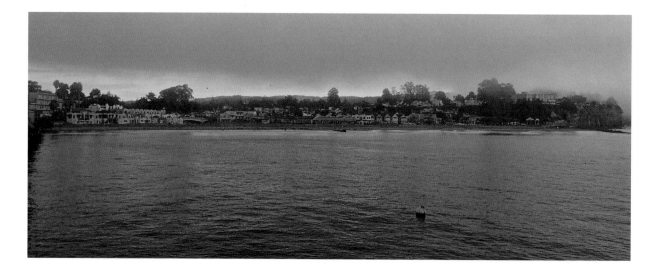

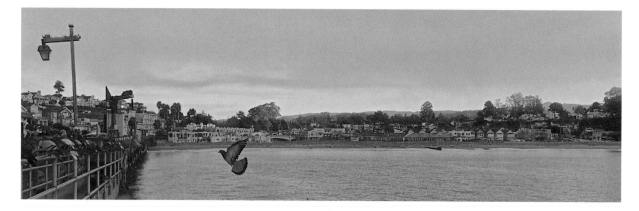

Nov. 1, 2015

Sunrise on the beach

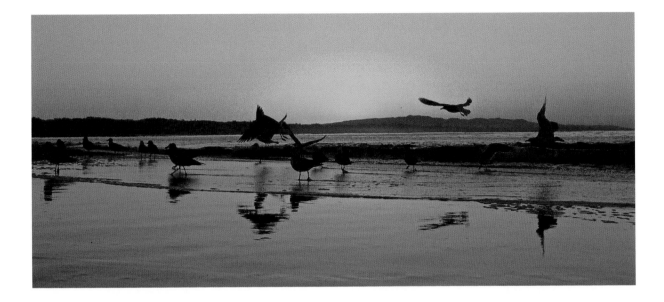

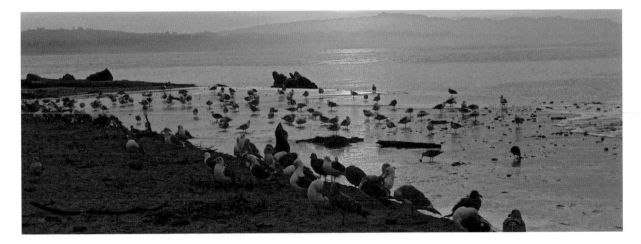

Oct. 7 2015 & Jan 9, 2013

The breakwater affords up close imagery

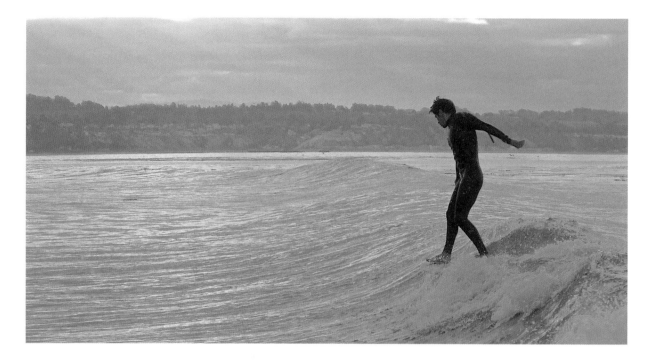

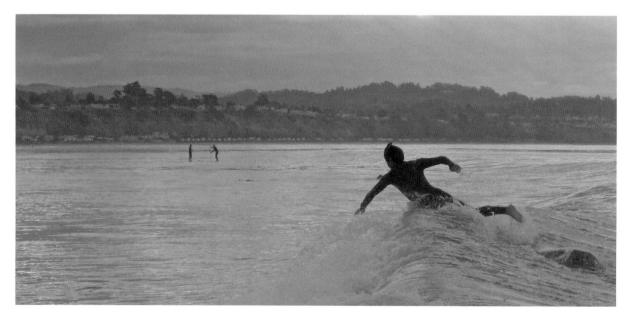

May 20, 2014

The colors flip in the blink of an eye

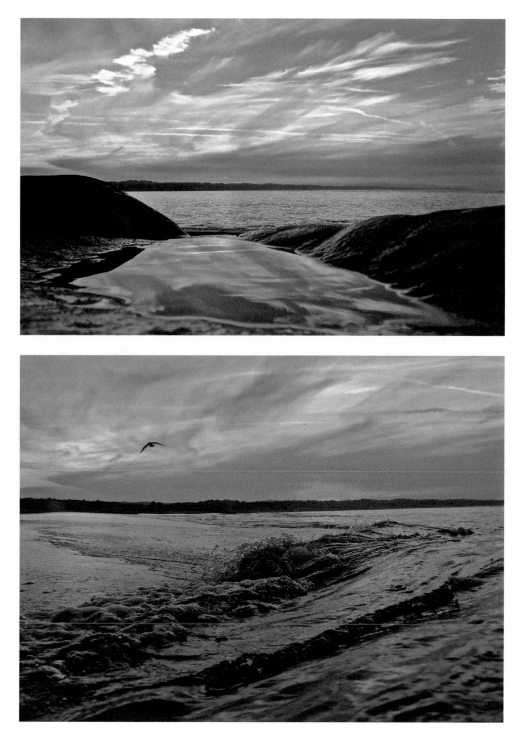

Oct. 8, 2015

Nightime in the Village

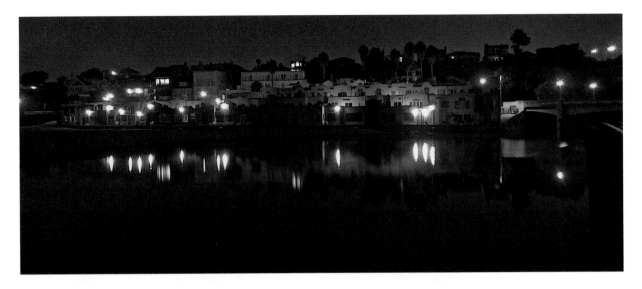

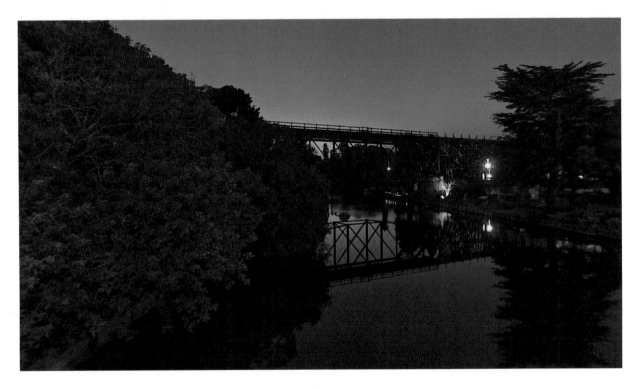

Jun. 28 & Jun. 9, 2014

Sunset in the Village

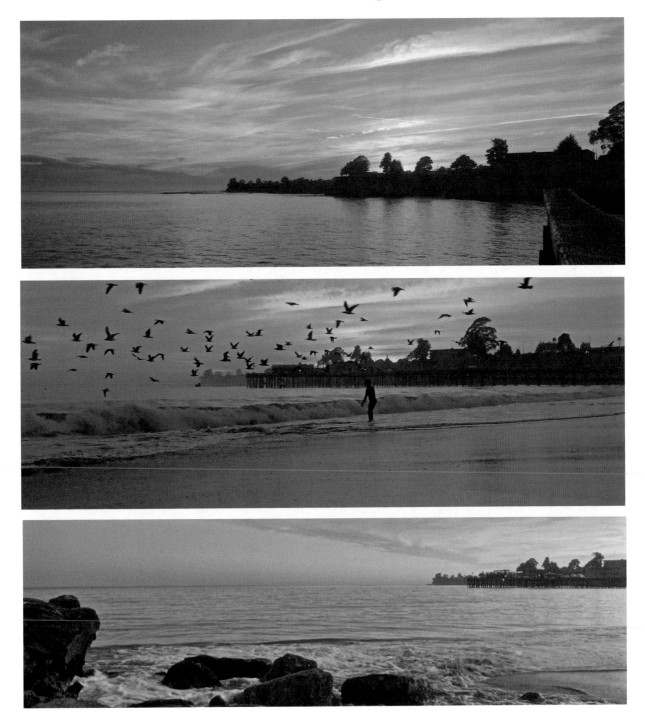

Dec. 8, 2015 & Jan. 21, 2014 & Apr. 10, 2013

The storm swell from Zelda's

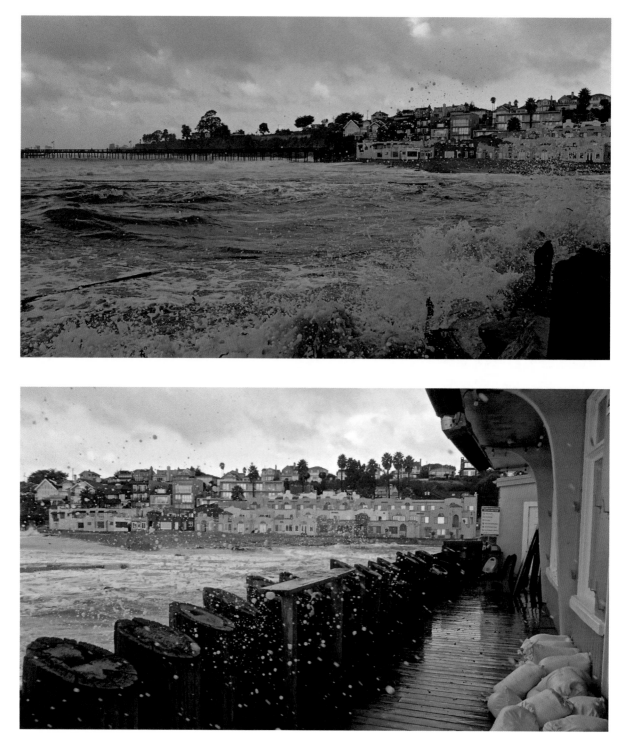

Jan. 23, 2016

Sunrise at Zelda's and Surfers

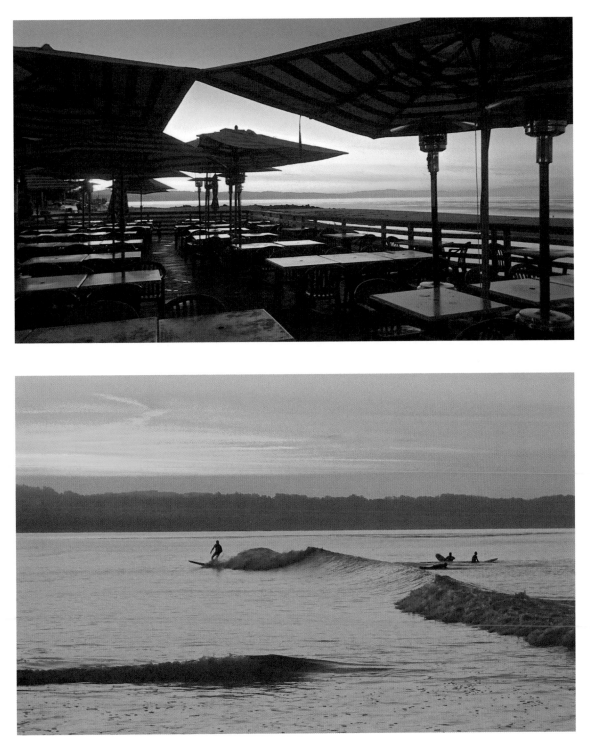

Mar. 20, 2015

Soquel creek and the Lagoon breach

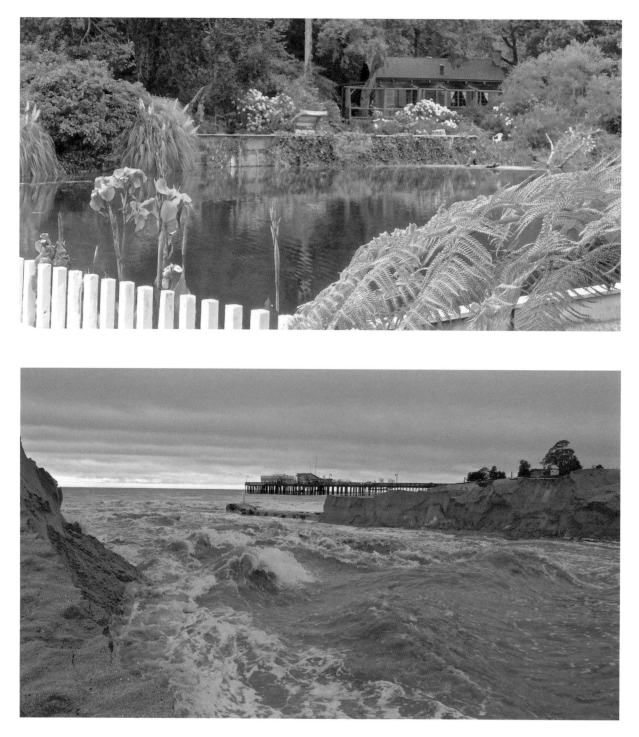

Jul. 10 & Feb. 8, 2014

Days of long shadows on the beach

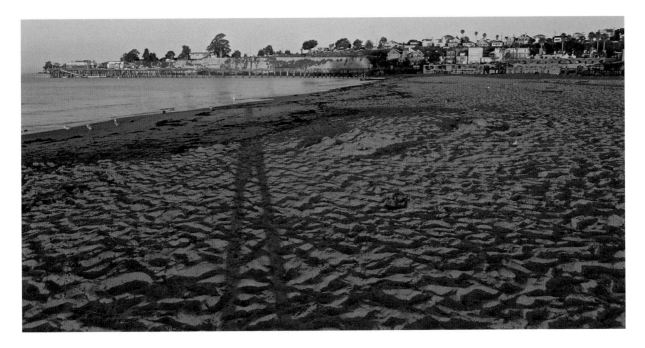

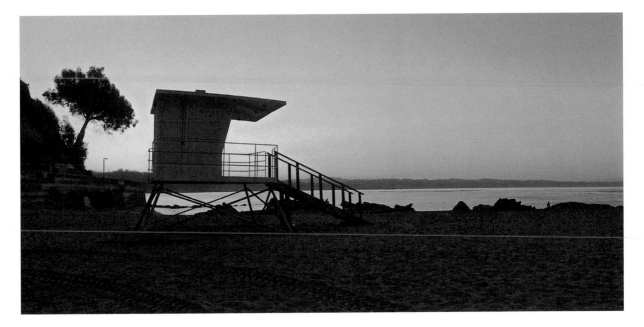

Jul. 24, 2015

Redwood stump and breakwater splisch

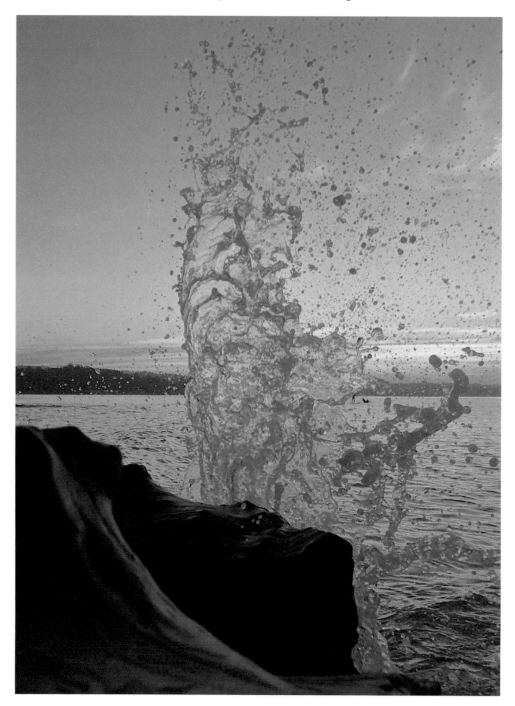

Oct. 7, 2015

The breakwater by the bluffs

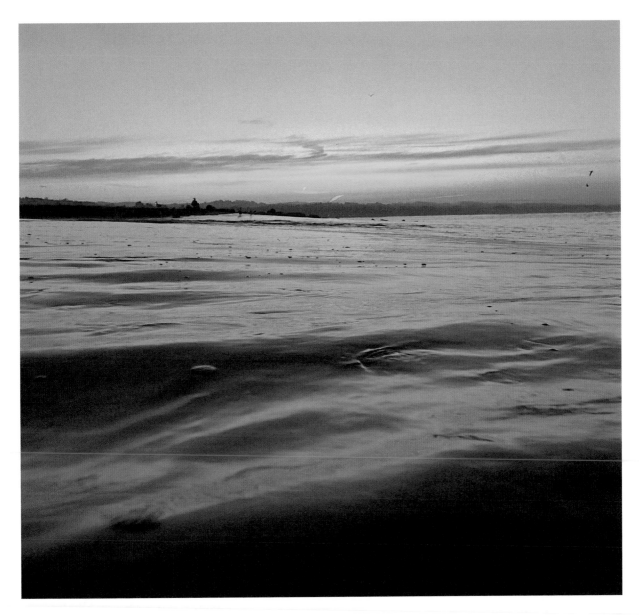

Oct. 7, 2015

Sunrise with Art Filter

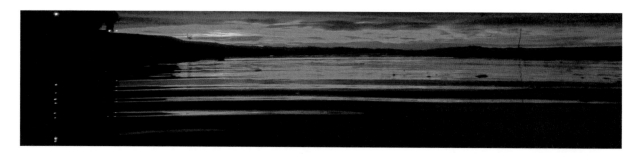

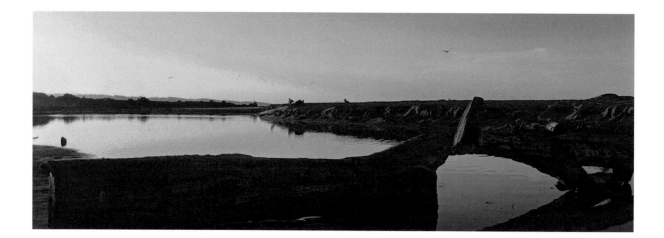

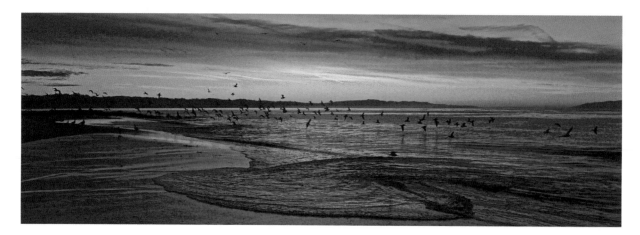

Mar. 15 & Apr. 15, & Dec. 2 2015

CHAPTER 9 THE HILL

The sunset and the topography of Depot Hill afford a panoramic image for the viewer. The change of seasons is framed along Cliff Ave. by the horizon line of trees, solstice to solstice and equinox to equinox. Hihn Park has evolved as a primary vantage point where I climb the Coast Live Oak and use the adjacent vegetation to provide visual speedbumps. The wild roses and lilac along the Cliff Ave. fence add colors and shapes to sunset. Grand Ave., formerly a road and now a walking path provides diagonals towards Pleasure Point and background reflective imagery.

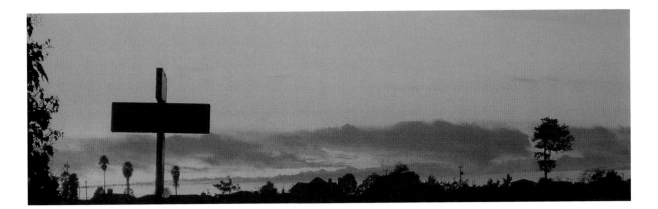

Feb. 23 & 20, 2016

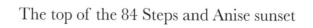

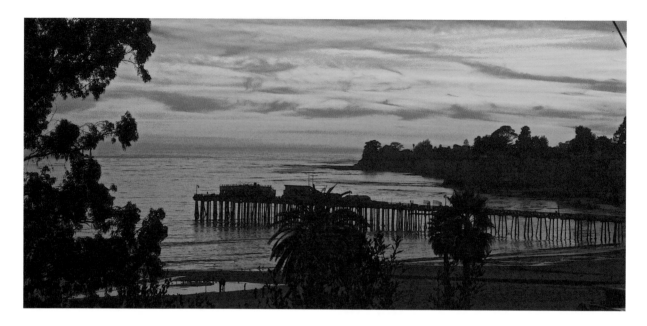

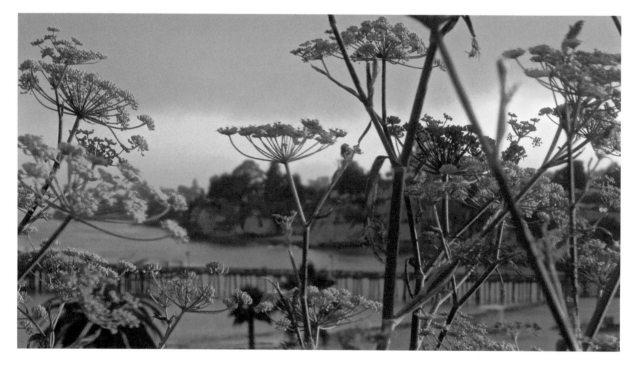

Dec. 6, 2014 & Jul. 10, 2013

Fire in the sky I

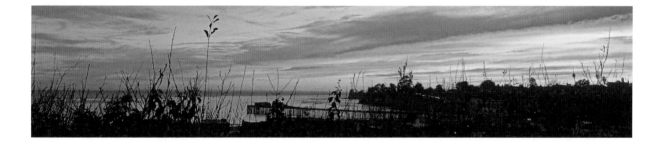

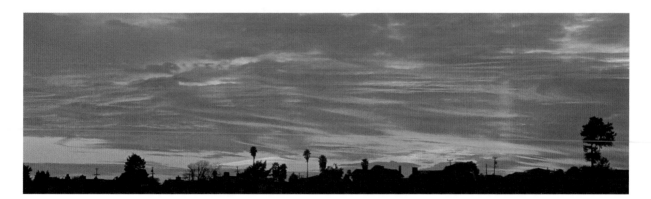

Sep. 30, 2015 & Feb. 9, 2016 & Feb. 18, 2014

Fire in the sky II

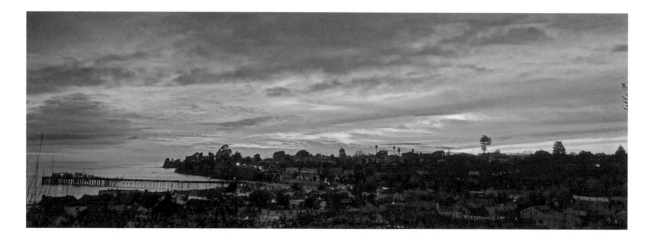

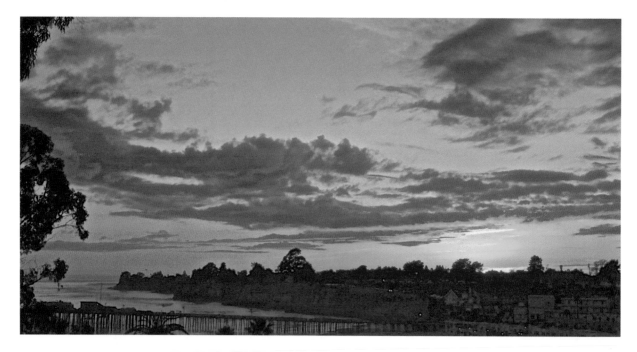

Feb. 3, 2016 & Jan. 25, 2013

Fire in the sky III

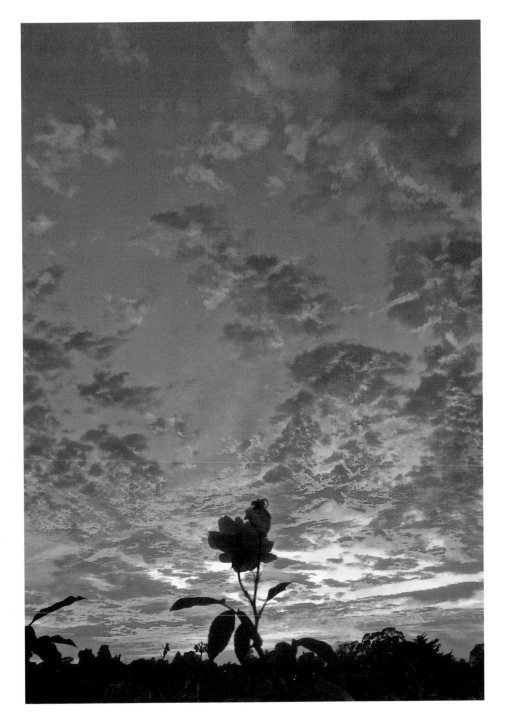

Aug. 29, 2014

Dec. 9, 2014 & Feb. 9, 2016

Slate Roof sunset

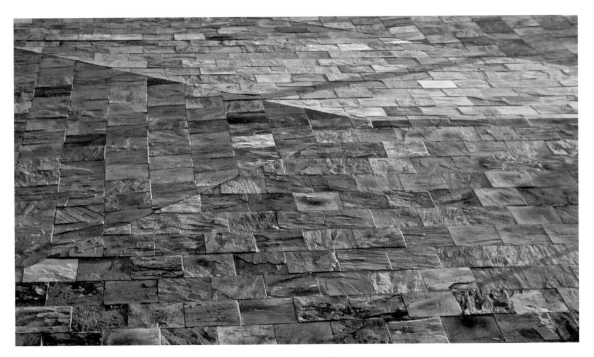

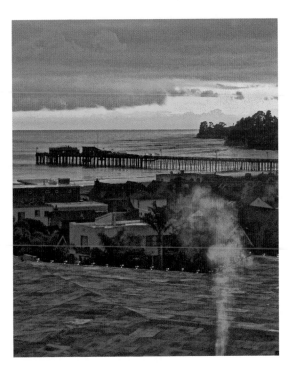

Jun. 12 & Jan. 6, 2013

Storm Clouds and Kelvin-Helmholtz waves in black and white

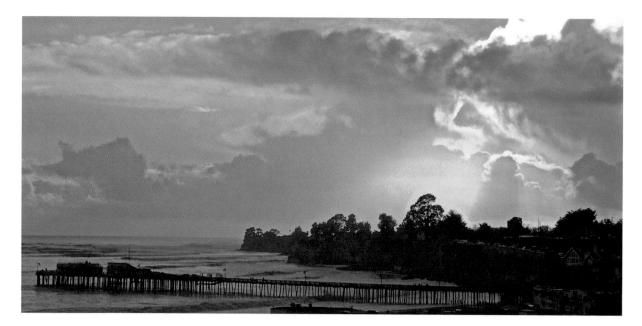

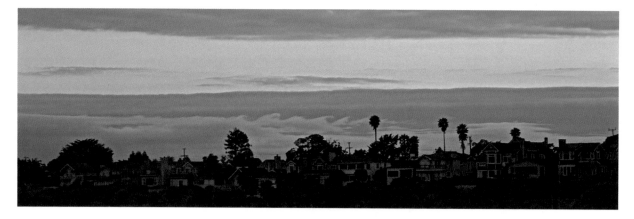

Jan. 5, 2016 & May 21, 2015

Crescent moon diagonals and solar descent

Nov. 17 & Sep. 23, 2015

The horizon line marker tree

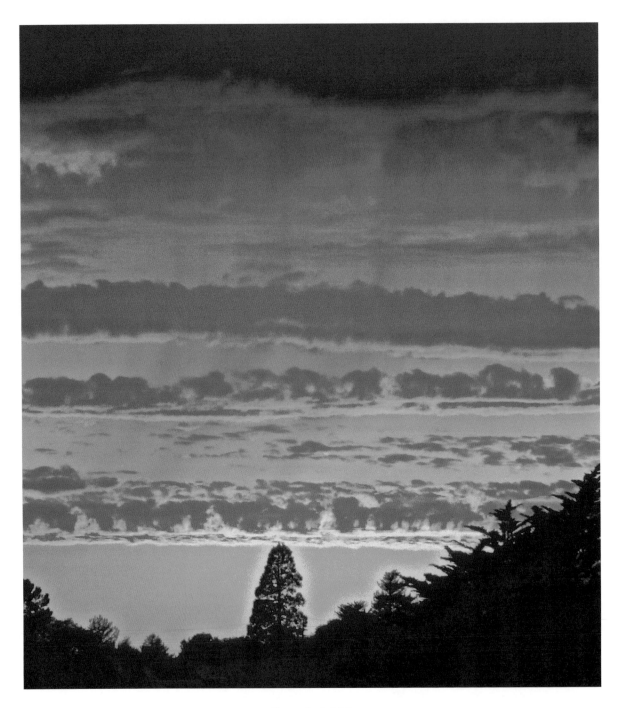

Sep. 3, 2013

Hihn Park

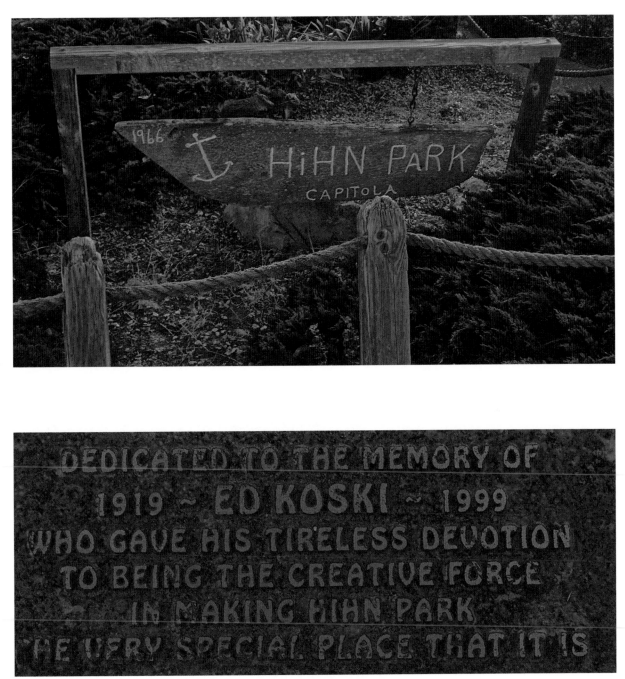

Aug. 3, 2015

Casey

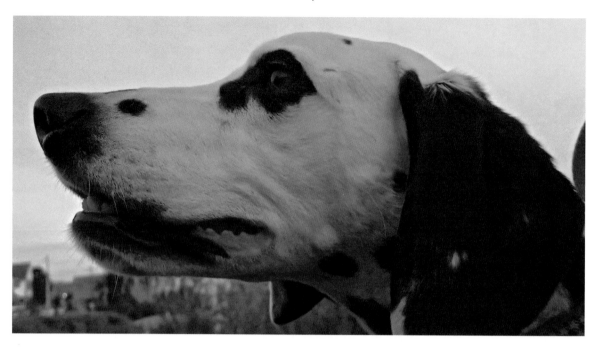

Aug. 3, 2015

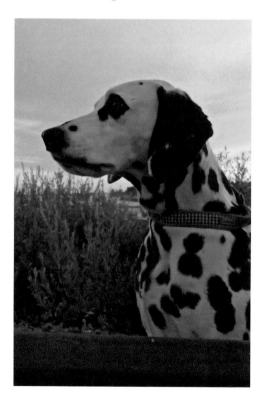

The Oak tree I climb at Hihn Park

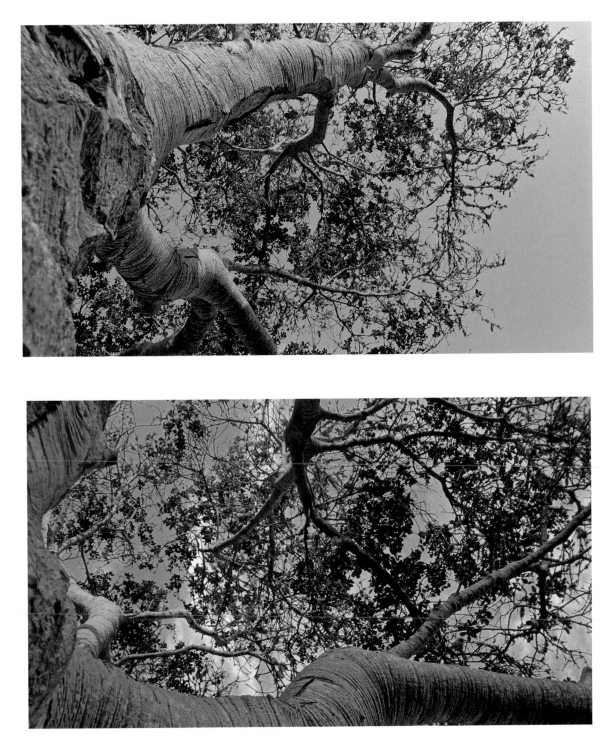

Jul. 27, 2015 & Feb. 9, 2016

The face in the Tree

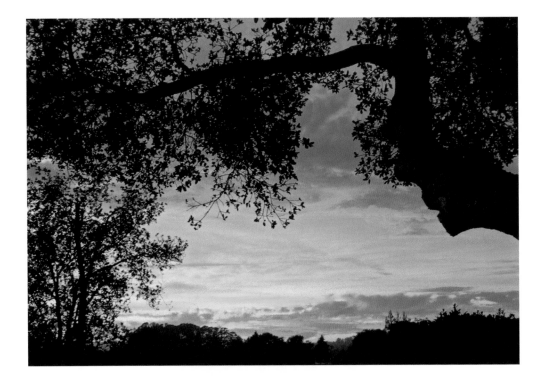

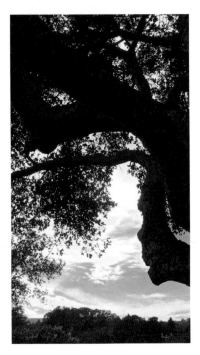

Sep. 23, 2015 & Sep. 27, 2014

The Porter pathway

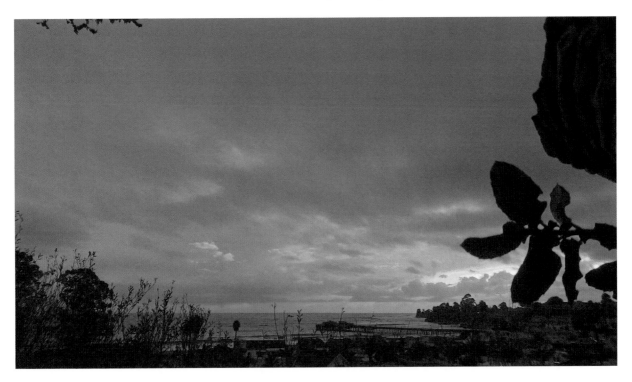

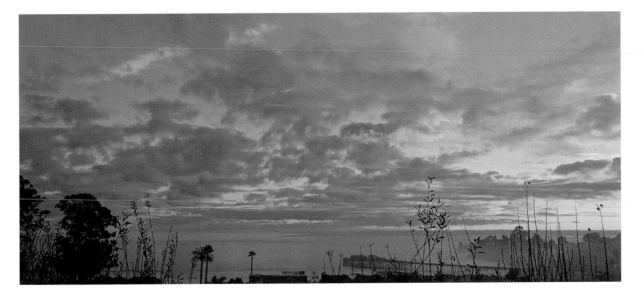

Dec. 15, 2014 & Jan. 11, 2016

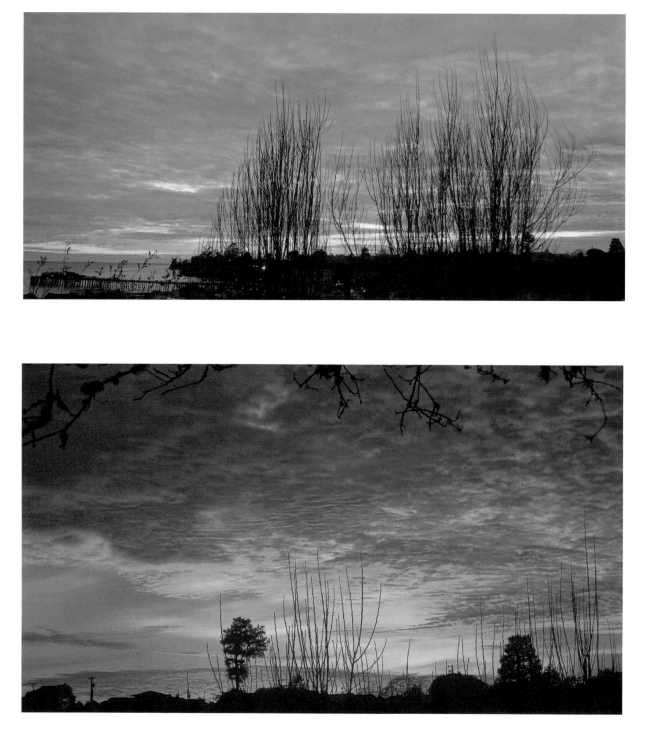

Feb. 4 & 20, 2014

Solar descent amongst the clouds

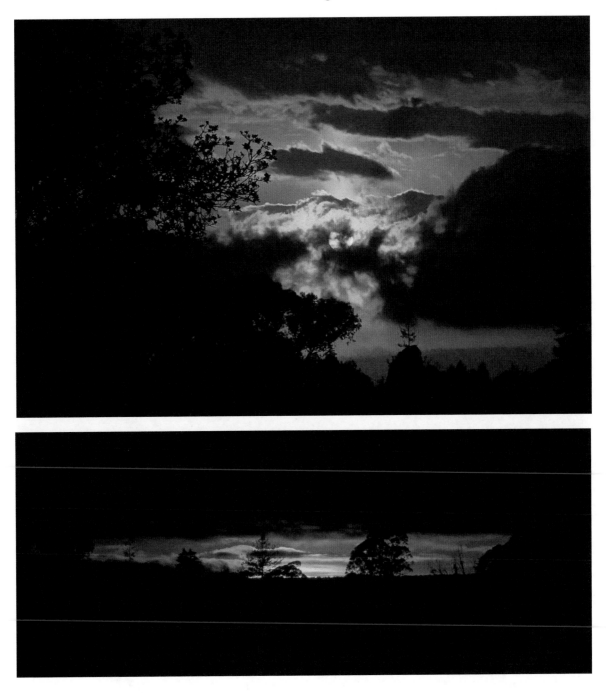

May 6 & Jul. 6, 2015

Magentas and fuchsias

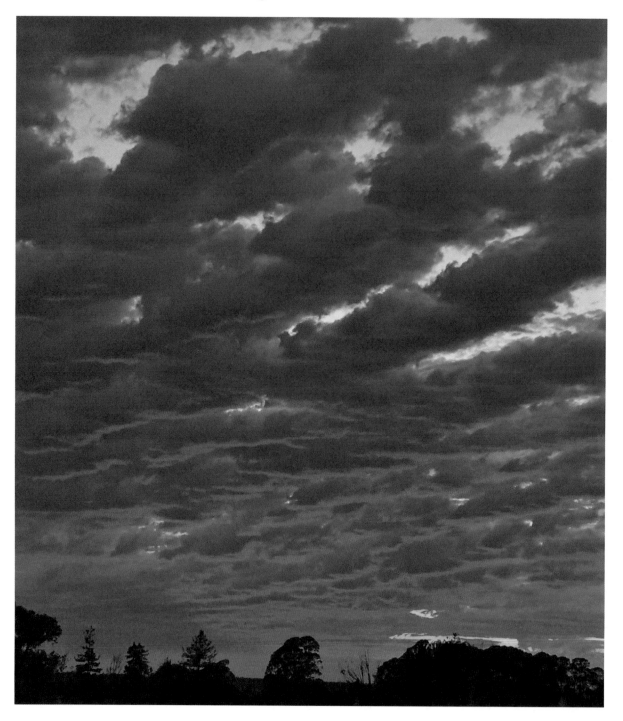

Jul. 1, 2015

Trees and Clouds

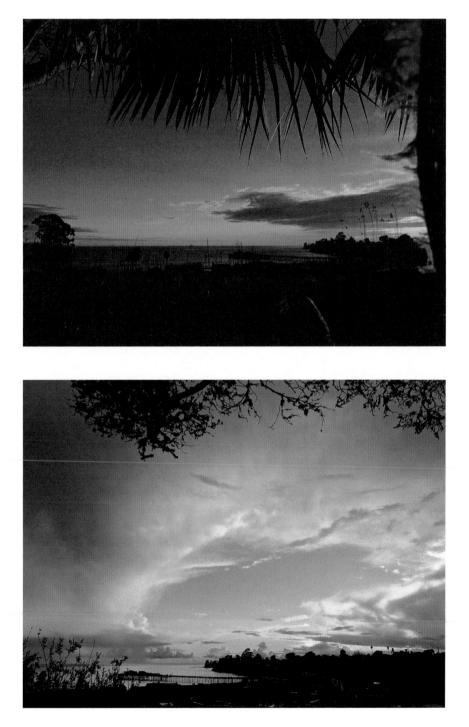

Jan. 27 & Feb. 28 2015

There is a brief moment to capture the opposite view from Grand Ave

Sept. 24, 2013

Sunset shadows and reflections with the Cement ship

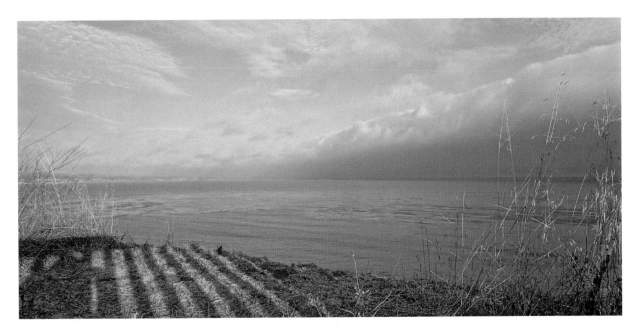

Sep. 26 & Feb. 10, 2014

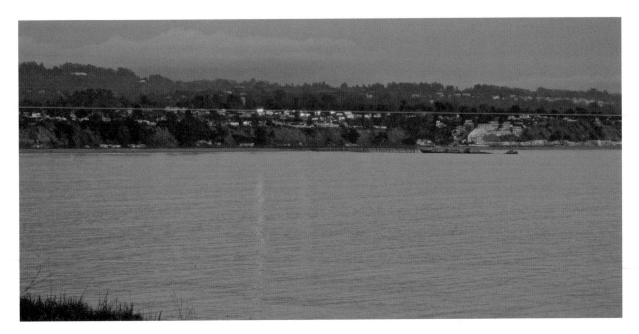

Full moon sunset and spring wildflowers

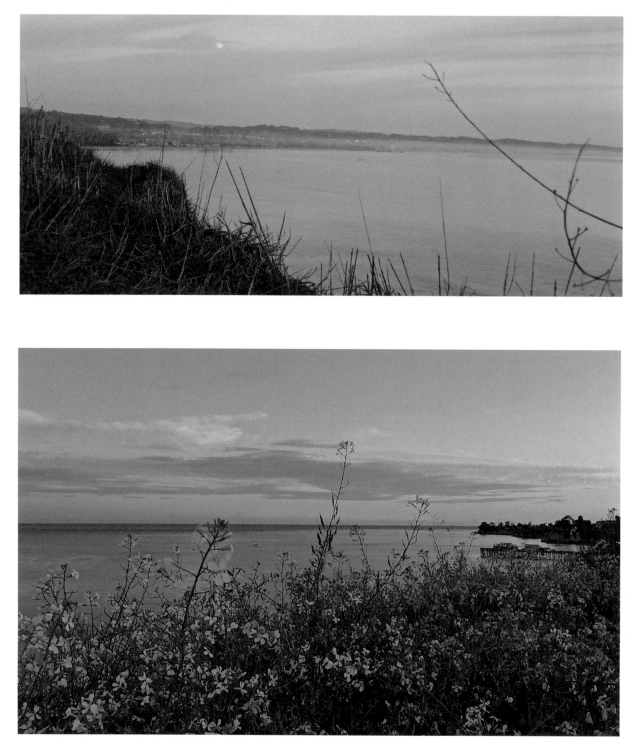

Feb. 13, 2014 & May 24, 2016

Sometimes, the moment happens

Oct. 7, 2012

Catamaran sunset

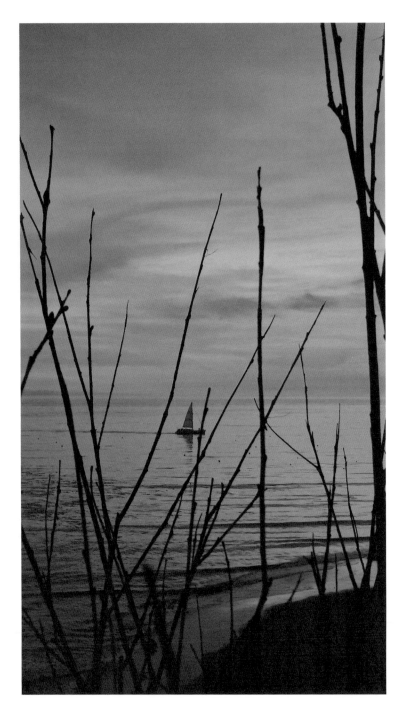

Dec. 6, 2014

CHAPTER 10 LILLY TOO !

Lilly, the Cat next door has been a presence since I moved to Depot Hill in 2011. She is, by nature and temperament not the feline that curls up in your lap. A yoga master who constantly demonstrates the art of the stretch and the climb. Her relationship with Squirrels and Skunks is less than desirable in the backyard. They are her friends much to the chagrin of my potted plants. A simple blade of grass or string excites and entices for a tug or chew. Lilly's radar is always attuned to know the cat nap locations. They are what I term "cat spots". Cat spots are those warm pockets of radiant heat that change with the seasons. Love you Lilly !

Cat on a string.

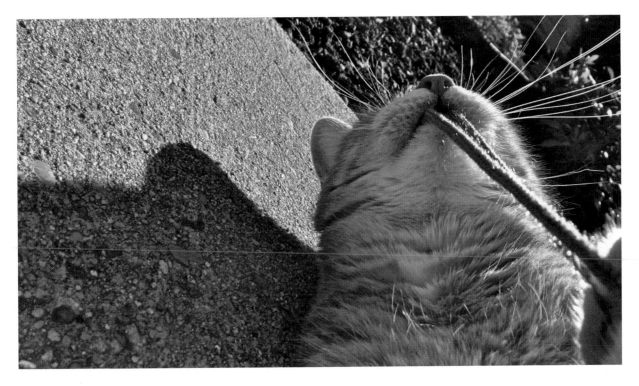

Dec. 19, 2012

Lilly Love

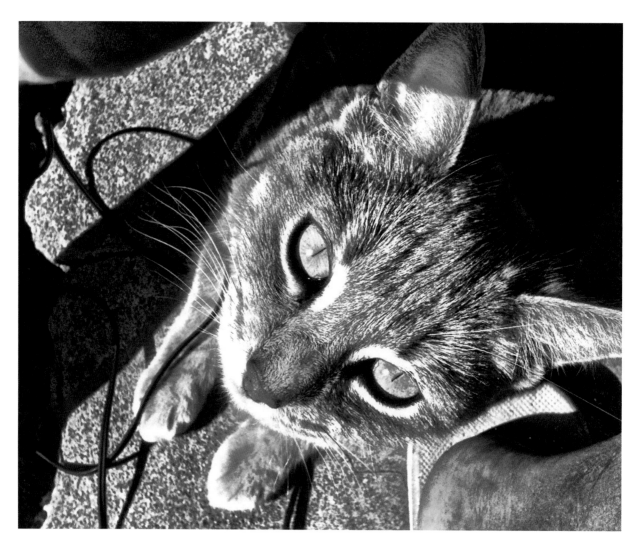

Feb. 27, 2013

Claws

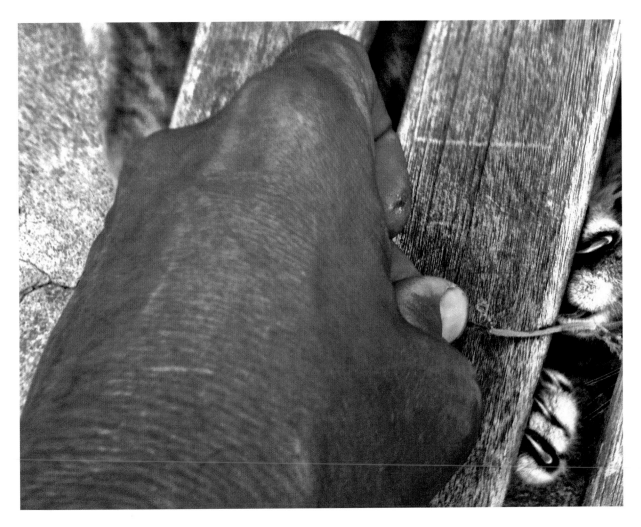

Aug. 20, 2013

Cat on the roof part I

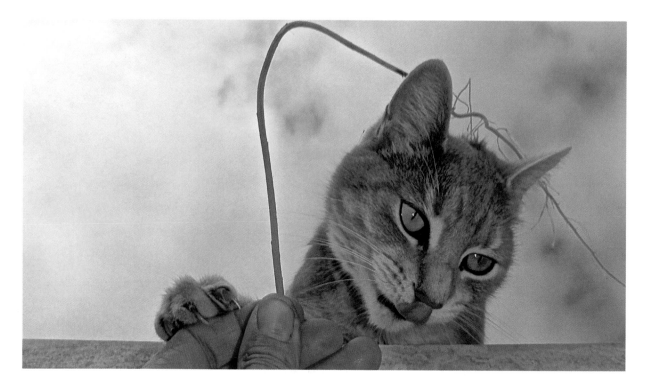

Aug. 22, 2013

Cat in the truck

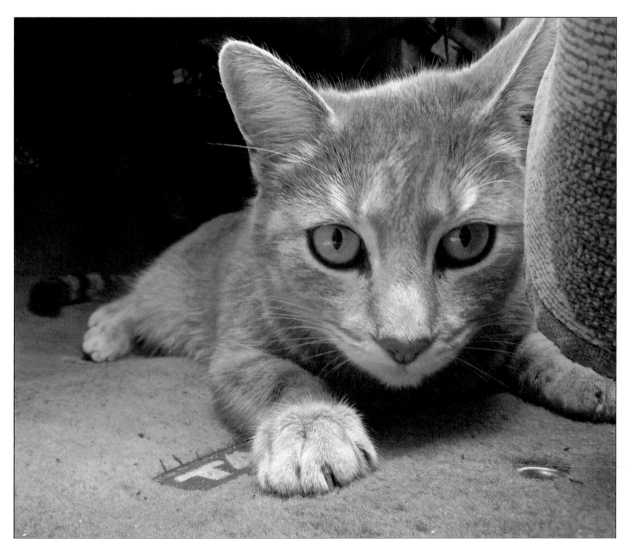

Oct. 5, 2013

Cat on the roof part II

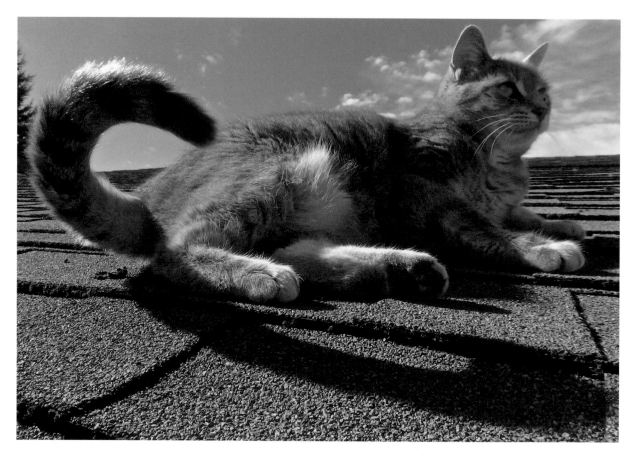

Nov. 5, 2014

The microscope setting

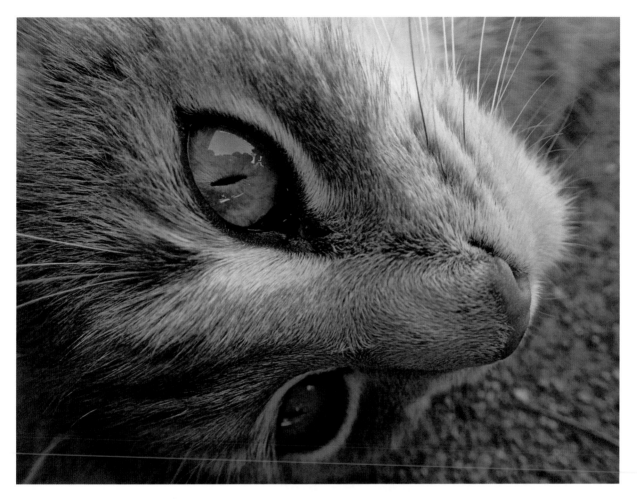

Jan. 21, 2015

Scratch post

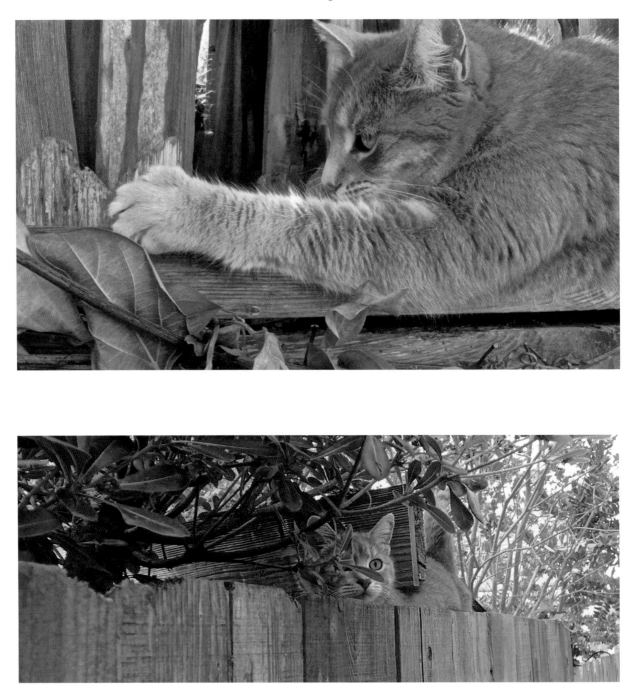

Jan. 31, 2015 & May 30, 2016

Licking chops

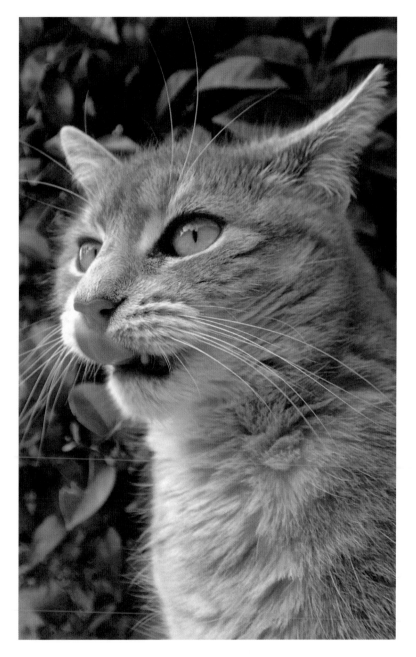

Feb. 26, 2015

Why my Truck is scratched up

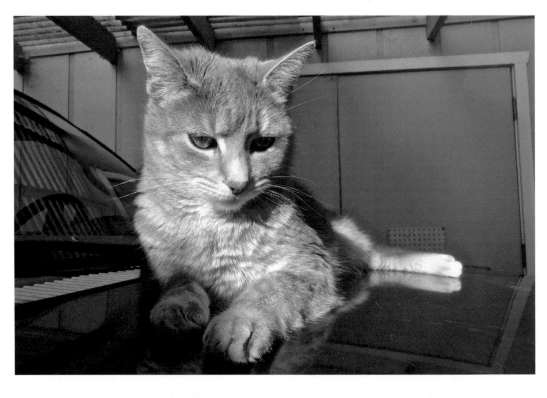

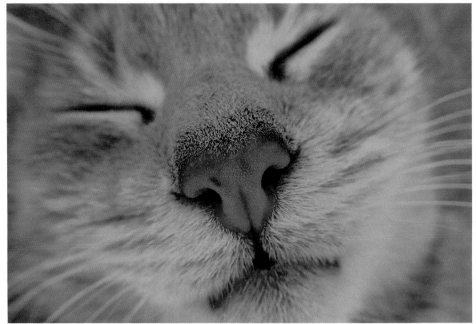

Dec. 9, 2013 & June. 5, 2016

Cat stretch

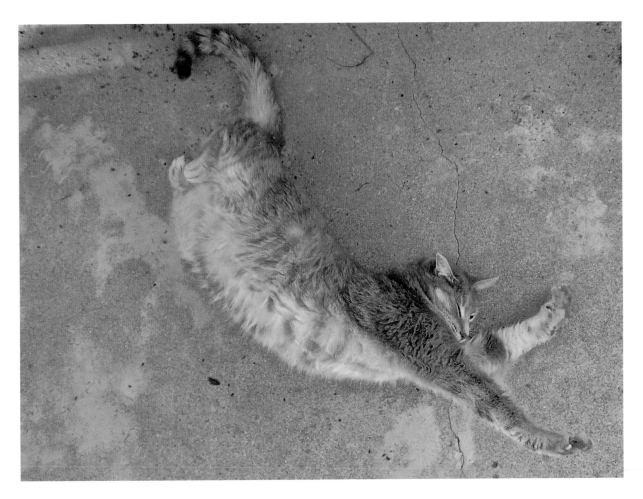

Oct. 30, 2015

Focus on the flying object and hybrid Columbine

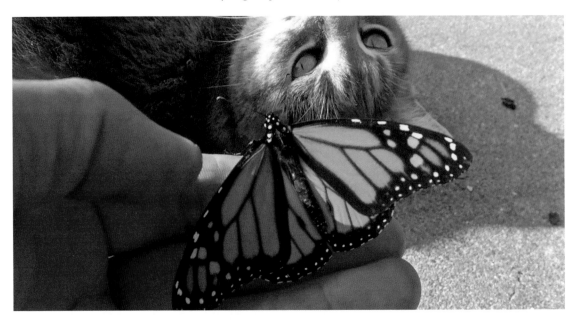

I propagate four species of Milkweed, Asclepias sp. and Monarch Butterfly's are an ever present feature in my backyard garden.

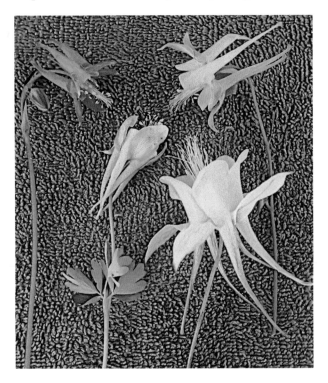

Jan. 30 & Jun 1, 2016

Dave Mrus is a recent Student at Cabrillo College in Aptos, California. He is an Artist of multiple mediums, Monotasker and Visual Synthesizer who lives in Capitola, California. Dave is a propagator of rare and endangered California Native plants and rediscovered the Cut Leaf Chinquapin, Chrysolepis chrysophylla laciniata in 2006. He continues the elusive challenge of Chinquapin cultivation. "California's greatest horticultural failure." - James B. Roof, Founder of the Regional Parks Botanic Garden.

Since 2013, He is the Artist in Residence at the Harbor Cafe in Santa Cruz. Dave looks forward to embark upon other opportunities upon publication of this book.

High resolution images of the 'pick of the litter" are available at:

http://Solaremergence.smugmug.com

Contact: dave@visualspeedbumps.com for questions about this book.

Grok your landscape.

To know something profoundly and intuitively. Mid 20th century: a word coined by Robert Heinlein (1907–88), American science fiction writer, in Stranger in a Strange Land .

Add you own photo imagery

Add you own photo imagery

Add you own photo imagery

Made in the USA
Charleston, SC
11 July 2016